THE MORNING STARS SANG

Overleaf: Jesus and the Disciples, Durst Rudy, probably
Pennsylvania, drawn and colored on wove paper, c. 1810, 8¹³/₁₆ x 6½
inches, Pennsylvania German Society and the Free Library of
Philadelphia.

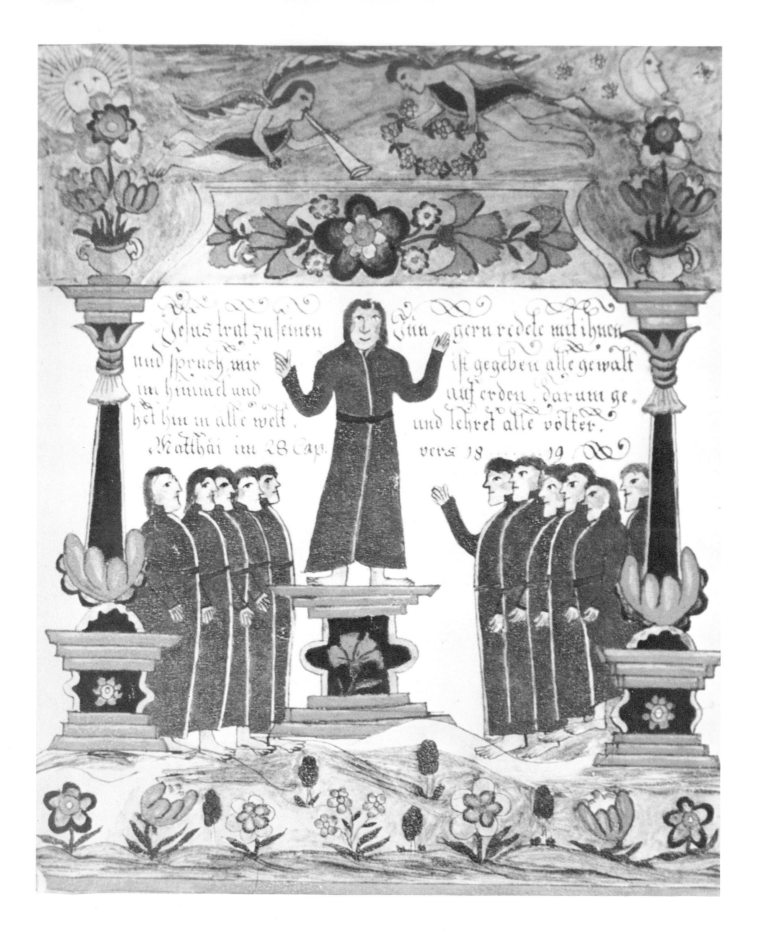

THE MORNING STARS SANG

THE BIBLE IN POPULAR AND FOLK ART

Anita Schorsch and Martin Greif

A Main Street Press Book

UNIVERSE BOOKS NEW YORK

Library of Congress Catalog Number 78-052197

ISBN 0-87663-316-5

Published by Universe Books
381 Park Avenue South
New York City 10016

Produced by The Main Street Press
42 Main Street
Clinton, New Jersey 08809

Designed by Quentin Fiore

For D. W. Robertson, Jr.
"And gladly wolde he lerne, and gladly teche."

CONTENTS

THE MORNING STARS SANG

Nothing — save the first three words of the Bible — ever begins at the beginning. Only by glimpsing the end is it possible to filter through the little particulars that go into making up a beginning. Creation is a mysterious business from end-time to new birth, from ultimate to immediate, from God to man; and, like good detectives, we anxiously strain to hear the eternal echo in every little event — the harvest in a seed, the promise in a rainbowed sky, the adult in a child, God in the morning stars, the Bible in art. This book, in itself a beginning, is a collection of biblical scenes rendered over three centuries by largely unheralded artists — all people of faith. Taken together, these works, largely ignored in our own time, form a pictorial story of what in earlier times would have been called "the plain man's pathway to heaven" and reveal an awareness of the Bible as the cornerstone of morality and as the first of many keys to heaven. These works of art — seen collectively — illustrate the Bible as "the book of books," which for three centuries at least was the one book familiar to every northern European from England to Scandinavia, from Germany to the young New World. It was read in churches and schools and read at home; and everywhere its words, as they fell on ears not deadened by custom, kindled a startling enthusiasm.

A gentle optimism that had begun in 17th-century England and on the Continent encouraged many of the most modest men to believe that life spent in work, family, and good deeds would prepare them to receive special compensation on a ticket to heaven. And, further, the good life of one man was believed to benefit all men. Hope for this good life led in part to America, and the underpinnings of the New World's founding reflected the spirit of the voyage. A taste for the natural as well as the supernatural, for the practical and for the pious, was the inheritance of its artisans, countrymen, and merchants. William Symonds, preaching in 1609 to English investors in Virginia, gave spiritual significance to the colonial impulse: "For the Lord had said vnto Abram, Get thee out of thy Countrey, and from thy kindred, and from thy fathers house, vnto the land that I will shew thee. And I will make thy name great, and thou shalt be a blessing. I will blesse them also that blesse thee, and curse them that curse thee, and in thee shall all the families of the earth be blessed." In the strong forearms of the colonists clearing the wilderness, the pulse of the righteous Adam was beating; the promised kingdom was in sight. Salvation of the world fired their souls. America provided dimension for a new mystical state of beginning with the end-time in view, an innocent wilderness uncontaminated by the history of human sin. It was as if the English merchants and ministers saw in colonization a return to the Garden before the Fall.

But the religious impulse, so manifest in the New World, was of course the spiritual and artistic legacy of the Old. Popular taste in the art of the 17th-century Old World Protestant reveals the emblematic character of his spiritual journey. Believing that God's truth came through the imagination, European artists often spoke, wrote, and thought in metaphor. And this was perhaps most apparent in English culture. Already familiar with one source of symbolic language

— the stage sets of the medieval plays — Englishmen identified biblical characters and events by transposing the clues of place (under a tent, by a well, in a walled garden), the clues of costume (royal red robes, a three-tiered crown, an innocent's clean-shaven face and youthful clothes, a corded cap, staff, and scrip [a pilgrim's knapsack]), and clues of condition (the bad sleep of foolish virgins and apostles as opposed to the good dreams of men like Jacob, Jesse, and Joseph). Painted cloths used as backdrops for the medieval stage were the predecessors of the biblical pictures of later centuries. In fact, painted cloths rich in biblical scenes continued for centuries as a tradition of domestic decoration. References to "ye payntid clothes . . .the paynted hangings . . .a little painted clothe" abounded in 16th-century household inventories, Shakespeare's grandfather having listed eleven such hangings in his will, and the art continued unabated well into the 19th century in Scandinavia (see, for example, p. 39). The trend of using decorative art to educate families in refinement of thought and spirit, a notion descended from the early use of painted cloths, became an established principle of decoration in the 18th and 19th centuries, a didactic thought well seen in such books as Catherine Beecher's *The American Woman's Home* (1841, 1869).

A second source of symbolic religious language was the picture book. Copied and recopied, emphasizing the familiar instead of the original, Anglo-Saxon illustrated texts — the Old and New Testaments, the Psalter, calendars, prayers, and litany — provided a visual connection between religious literature and decoration. Books of hours, private devotional volumes painstakingly crafted outside of monasteries, followed in the late 14th century as one of the most frequently illustrated types of religious books. These gloriously illuminated works generally pictured the Evangelists, or scenes from Genesis, or such Old and New Testament parallels as David and Jesus, Job and Jesus, the ascensions of Elijah and Christ, or the Creation and the Crucifixion.

Throughout Europe in the Middle Ages, but particularly in Germany and in the Netherlands, there flourished a type of crudely illustrated book based on the Bible that was immensely popular with the preaching monks in teaching their largely illiterate charges. The *Biblia Pauperum* — the Bible of the poor — was the name given to these block books that consisted of a number of rude pictures of biblical subjects with short explanatory Latin texts accompanying each picture. A similar work popular before the Reformation, but more extended with rhymed text, was the *Speculum Humanae Salvationis* or "Mirror of Human Salvation." Both were, in effect, "poor people's Bibles" and provided stark visual representations of the dramatic highlights of stories with which the common man had long been familiar through the spoken word.

The illustrated Geneva Bible of 1560, which was published in a convenient quarto size and contained explanatory marginal notes, was very popular with the Puritans and Separatists of England and Scotland and, in America, of Ply-

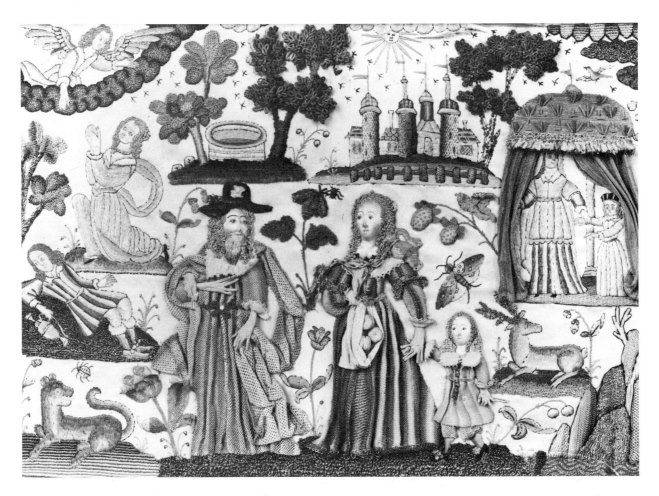

Abraham and Hagar, artist unknown, English, silk, silver thread and metal purl on white satin, mid 17th century, 10½ x 14¼ inches, Victoria and Albert Museum.

mouth and Virginia. The translators, concerned with spiritual profit for their lay brethren, concentrated twenty-six wood-cuts in the first five books of the Old Testament, and in Kings and Ezekiel, texts that to their minds were "so darke that by no description thei colde be made easier to the simple reader." It is perhaps no coincidence that thirty-three of the forty-one Old Testament subjects included in this book are based on these same "darke" passages of holiness and sin.

The *Thesaurus Sacrarum Historiarum Veteris Testamenti* of 1585 provided specific illustrations of Ishmael and of Isaac that were frequently copied for needlework pictures popular on the Continent. Like Cain and Abel and the Prodigal Son and his "righteous" brother, Ishmael and Isaac were biblical siblings, a motif which commonly polarized human conflicts. English Protestants in particular treasured the figure of Isaac, the son of a freewoman, who symbolized promise, sacrifice, and hope for the elect. They also treasured Ishmael, the son of Abraham and a bondswoman. He symbolized both the flesh and forgiveness, having established, according to tradition, a nation of heathens redeemed. (Despite the fact that some critics still categorize the 19th century as an age of little allegory and less faith, these two symbolic sons of hope continued to be popularly illustrated well into the 1800s, particularly in America, where they underlined the universal character of the new nation as a home for two innocent but contrasting biblical children. (See p. 53.)

And, finally, emblem books — poetic, moralistic, and illustrated as were the earlier devotional books — provided a third source of visual inspiration, encapsulating shortcut virtues, manners, and modes of behavior that would lead to the good life and prepare people for citizenship in the new Kingdom. The 17th-century emblem books of George Wither and Francis Quarles appeared in many European and American household inventories. Wither's *Emblems* (1635) was itself one of a series of attributes painted in a 17th-century still life by Edward Collier depicting typical material and spiritual blessings of the English landed and town gentry. That the mind of the 17th-century Protestant saw spiritual meaning in every "commonplace" is evident in the preface to Quarles's *Emblems* (1635): "Before the knowledge of letters GOD was known by Hierogliphicks. And indeed, what are the Heavens, the Earth nay every Creature, but Hierogliphicks and Emblems of His Glory?" No less did America's Revolutionary artists see God and nation in decipherable emblems, or such 19th-century American theologians as Horace Bushnell speak in the language of emblem and metaphor. Bushnell declared that symbols kept men good and gave them spiritual exercise by challenging the intuition of their imaginations. Factual writers with blocks of opinion, he said, became timeworn, while Bunyan's metaphorical pilgrims would live on "till the sun itself dies out in the sky."

A good number, if not most of the biblical scenes in this book — although literal translations of scriptural stories — contain elements that can be considered symbolic or "hierogliphick." Some of the motifs, in fact, have been consistent in literature and art for centuries and have disappeared from the common mind only in recent generations. Most,

when properly understood, remain as metaphorically potent as they were when first introduced or expanded upon by early scriptural commentators. All are decorative and add immeasurably to the general composition of an illustration, but require of the contemporary mind an intellectual flexibility to comprehend them in the context of the times in which they were employed.

The 18th-century needlework pictures of Prudence Punderson (see pp. 51-62) are typical in their employment of visual symbolism that can easily be missed by the contemporary eye. Her superb pictures of the twelve apostles are discussed in captions, but the first — that of St. Peter (p. 51) — may be considered typical of many of the popular works in this book. Most readers will immediately recognize the keys held by the apostle as an obvious attribute (the keys to the Kingdom), but will overlook the meaning of the empty chair. This chair, here charmingly rendered as a transitional brush-foot solid-splat side chair, suggests the fact that, after the death of Judas Iscariot, Peter had recommended that Matthias fill the traitor's empty chair. The dog at the apostle's side, of course, suggests fidelity, in opposition to the actions of the "owner" of the vacant chair. Such details in an otherwise "simple" or "naive" illustration are hardly accidental and are based on centuries of accumulated tradition and exegetical commentary. Only a few highlights of this tradition, of course, can be hinted at in the pages that follow. But they should put to rest once and for all the term "naive" as applied to a popular art that was in its own way remarkably sophisticated and hardly without intellectual content.

Landscape motifs were among the first of visual "hierogliphicks," the most vital of which was the Garden of Eden itself. The garden was sometimes represented by only a tree, but then wood had always possessed miraculous powers as evidenced in Moses's rod drawing water from a stone, David's three rods turning men's skins white, Jacob's rods making white sheep spotted, the holy root and rod of Jesse, and the magic tree of twelve fruits in the garden of the Apocalypse. That 17th-century treatises on fruit trees were written for actual and spiritual use may be seen in the preface to Ralph Austen's garden handbook, *A Treatise of Fruit Trees* (1657). Bound together with this essay was an earlier one, *The Spiritual Use of a Garden,* which struck one of Austen's 17th-century readers as an experience he could liken only to hearing trees speak the Gospel. Walking through Austen's garden was for him like gathering "clusters of gospell grapes."

It has been commonly accepted that though the sun was an emblem of God, the tree was an emblem of all that God created. Connoting divine light through shade, growth, blossom, and fruit, the first tree — traditionally the apple — was a sign of knowledge in the Garden of Eden. Like its fruit, the tree bore the smell of human trouble and the sweetness of human salvation.

According to tradition, the tree of life — the second tree — was offered after the Fall to the obedient and the repentant. The popular 17th-century English writer of metaphorical scripture, Benjamin Keach, whose books were

The survival through the centuries of Christian iconography can be readily seen in these three illustrations, ranging 500 years in time from the 13th century through the 19th. The 19th-century watercolor, *opposite,* graphically illustrates the duality of the human condition, represented by two trees and suggested by Jesus's statement in Matthew 12:33: "Either make the tree good, and his fruit good; or else make the tree corrupt, and his fruit corrupt: for the tree is known by his fruit." The "good" tree at the right is nourished by an angel. (See the early 17th-century emblem, *below,* in which the winged "gardener" waters the enclosed garden of the soul.) The "corrupt" tree at the left is threatened by a beast with open jaws representing the darker side of human life. (See the 13th-century illumination, *below,* in which a similar fierce-eyed monster is literally in the dark and in opposition to the chaste unicorn.)

Psalter and Hours of the Virgin (Amiens, c. 1275), Pierpont Morgan Library.

Amorum Emblemata, Otto van Veen (Antwerp, 1608), Henry E. Huntington Library and Art Gallery.

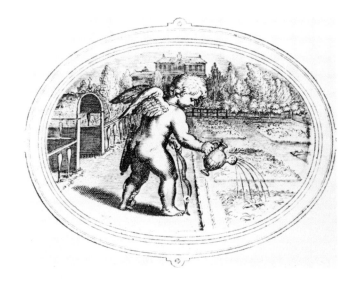

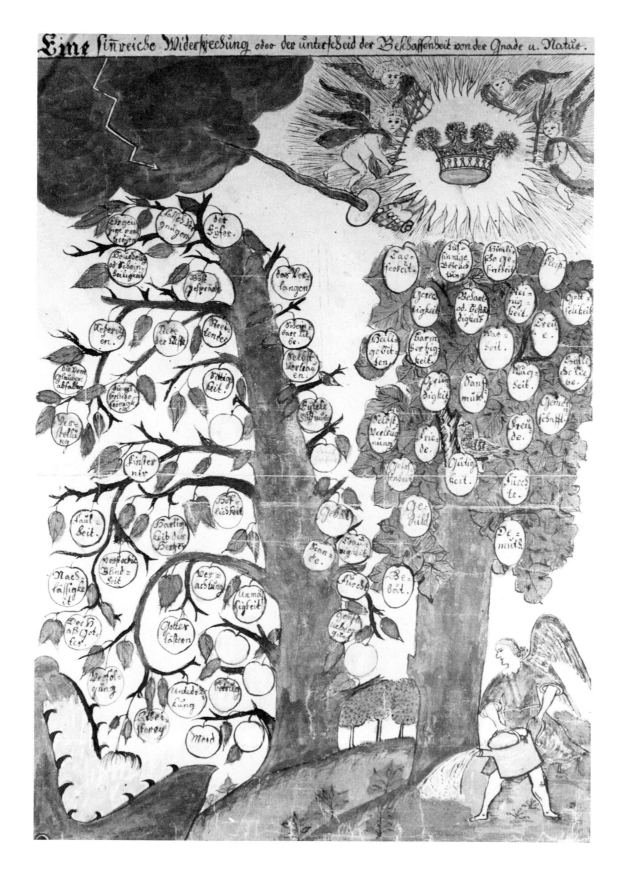

An Ingenious Conflict: or, The Difference Between the State of Grace and the Natural State, artist unknown, probably American, watercolor on paper, c. 1800, 7 x 15 inches, Private collection.

15

reprinted in America for two centuries, from 1678 to 1858, believed with Isaiah that all godly people were "trees of righteousness," planted by the Lord to glorify Him. The shade of the tree, like the wall, suggested protection, transcendence of the flesh, a place under the sun that was warm, but not overheated. Human lust was left in the earth.

But the garden was often more than trees alone. As in the Garden of Eden, the Garden of Solomon, or the Garden of Gethsemane, there were flowers, animals, birds, streams, and walls. The garden itself w5s a most delicate flower — man's soul. The gardener, from 16th-century European engravings to 19th-century American watercolors and jewelers' designs, was God's helper, a monk, a winged child, or an angel with a watering can. The gardener represented divine guidance and divine "watering." The seeds were Scripture, and the grass — a green bed — was destined for humanity's divine marriage, the marriage of the community of believers with God. The spiritual garden, then, was cultivated as a place of "eternal spring," a place "no lesse delicious in Winter, than in Summer, in Autumne, than in the Spring."

Flowers symbolized virtues, and a whole garland of them suggested the New Law (salvation through Jesus rather than through the "Old Law" of Moses). God's breath was the wind blowing over the garden carrying chaste fragrances. Well understood and used by Mary, Queen of Scots, and the ladies of her court were such "spiritualized" flowers as the columbine of sorrow, the sunflower of fidelity, the carnation of love, and the daisy of faith. Roses and lilies belonged to the Church. When in pictorial illustrations Gabriel announces to Mary the coming birth of Jesus, a lily is often set between them (see p. 86).

Grapes were among the "good" fruits in garden iconography, and pears were symbols of lust. But the garden, like the soul, was not meant to be without its distractions. Creatures of the flesh abounded. A fierce-eyed monster, mouth agape, or a wild boar challenged the gardener to keep his place (and of course his soul) clean. To the medieval mind, such "unclean" creatures as the fly, frog, leopard, hare, or boar were the wild and worldly symbols scattered among the other-worldly emblems of purity such as the unicorn, the hart, the butterfly, the bird, and the bee. And this opposition of "good" and "bad" creatures — many having received their positive or negative attributes directly from biblical passages — continued in tradition for many centuries.

Emblematic motifs polarized the past and the present, the good and the evil, the fearful and the pure. Like medieval Psalter illustrations, 17th-century engravings and needlework pictures and 18th- and 19th-century folk and popular watercolors froze the many phases of time, action, and morality into one scene. By placement — the sun on one side, the moon on the other; the good tree on one side, the evil one on the other; the monster on one side, the angel on the other;' yesterday to the left, today to the right — moral life could be simplified or at least choices could be made clear. These polar opposites are of course intrinsic to 17th-century American logic.

In both art and literature, emblems and larger symbols maintained the medieval connection between material beauty and spiritual beauty, plotting historical points of contact with beliefs of the past. Sacred trees, hills, and rocks remained God's meeting places; the old man and the blindfolded woman — both commonplace symbols — were never meant to see the eternal spirit (blindness and lameness, like old age, were physical symbols of spiritual incapacities of the soul); the naked baby recalled the purity of Adam and Eve before the Fall; the horse, though beautiful, was threatening in its sensuality; the river led to baptism; the highway to divine wisdom and heaven, the woman to human wisdom and sorrow, the eagle to spiritual victory, the pelican to self-sacrifice, the scales to the justice of good and evil.

By the 17th century, when aesthetic judgments had become as acceptable as spiritual judgments, emblematic designs were found most everywhere. The four Evangelists and the female figures of Faith, Hope, and Charity were modeled in relief on ceilings and panels of English houses as well as on church monuments, landscape sculpture, glass, and metal work. Henry Peacham's woodcuts were traced on ceiling plasterwork. The emblems of Alciati and Whitney became embroidery designs. And scriptural needlework, which adorned pillows, furniture, and bedchamber walls, gave evidence of widespread Protestant approval of the use of ornamentation, rare dyes, and fabrics. Art and decoration in tune with moral and spiritual instruction found admission even in Puritan homes. As long as art was not created entirely for its own sake, the Western religious mind could avoid feeling tainted by idolatry.

Everyman's door was suddenly open to the literature of a revelatory God. The rustic-turned-clergyman, who had comprised the 16th-century intellectual class, was no longer by himself. Both men of commerce, who as a group had not been given the chance to read, and aristocrats, who as a group had never wanted to read, suddenly viewed literacy as a miracle that would open doors to class, estate, or kingdom.

Reading meant learning a little language — Latin and English — a little law, a little mathematics, and a great deal of religion — the Bible, sermons, devotions, pious epitomes, and courtesy literature. The Bible in English translation and books of hours were made available, though at a good price, to the lay public. Private libraries of 16th-century merchants, gentlemen, and priests most often consisted of such combinations of books as the following: "song books, Catechismes, English primers, a Casiodorus Commentaries vpon the Salmes, lattynne Byble and the new testament Englishe, booke of service and Salmes and meter, paraphrasis of Erasmus, toomes of homelies, the books of posthils" Prebendaries, honorary members of a collegiate church, sometimes had in addition, "Seynt Augustyne works and Basyll in greik & latten and Rabbye moyses in printe."

The extent of a man's pocketbook continued for an additional 200 years to dominate the extent of his library until the technological innovations of the printing press and the paper machine popularized the book market. And

treasured books were in the 16th century, a carton of small English books costing as much as boots and shoes or three blankets, and a dozen catechisms equal in value to fourteen pounds of black wool. By the 17th century, both in England and in America, Puritan sermons, Bunyan's *Pilgrim's Progress,* Foxe's *Book of Martyrs,* the works of Perkins, Purchas, Bayly, Baxter, Prynne, and Hakluyt, and the spiritualized trade literature of Flavel, Collins, and Woode were considered almost as useful as the Bible. (Ninety-seven works of the English divine John Flavel, for example, appeared for sale in New England in 1683.) Spiritualized husbandry, navigation, shepherdy, and weaving made the work of apprentices and women more honorable and pious since such "spiritualized literature" analyzed each step in a commonplace trade and found divine meaning in all of them. Those who labored with their hands found that Bible stories addressed themselves to contemporary problems. For instance, *Ester Hath Hang'd Haman,* written in 1617 under the pseudonym of Esther Sowerman, was the title of a plea for mutual support between women and apprentices.

If a man did not own books or was unable to read them, he could borrow a book or sit with someone like Adam Eyre of Yorkshire and listen to a reading. "After diner, came hither William Barber of Horderon, to get mee read him some writings and stayd here til almost night." According to Eyre's diary of 1647, he read to men of different trades and professions. He also kept a record of the books he lent to friends. 'This morning Reginald Appleyard and Francis Coldwell came according to my request, and I lent Reg.[d] the *Jus Divinum* for Presbytery . . . allso the 1 vol. of the *Booke of Martyrs* I lent him to read...Reg. Appleyard brought my bokes home from Franc. Coldwell and himself, and I lent 3 of Dell's again to Wm. Rich"

The borrowing habit led in the next century to the circulating library and to more independent reading. Being read to, a practice which continued into the "more literate" 19th century, kept a certain controlled interpretation in the hands of the reader. Many an educated American young lady like Harriot Manigault, whose diary reveals her own ability to read "French . . . Gibbon's *Rome* . . . Chateaubriants's *Tour and Travels of Anacharis* . . . [and the] *Spectator* . . .," listened every day to a special reading of the Bible designed to insure the proper spiritual connection between the Old and New Testaments. Private Bible readings caused uncertainty according to Connecticut school headmistress Sarah Pierce. She took pains to interpret God's voice echoing from Genesis through Revelation in order "to obviate those objections which arise in the minds of youth against the justice of God, when they read the wars of the Israelites." The history of such wars written by the Jewish historian Flavius Josephus was a popular book in American home libraries.

Biblical typologies were not new as far back as the 4th century, but when compiled by Abbott Suger and his successors in the 12th century, the connective thinking between visual pictures and literary ones was clarified and made secure for centuries to come. The irreversible impact on church architecture and woodcut illustration carried the thread.

Suger's scriptural parallels were applied by Bernard Montfaucon in *L' Antiquité Expliqué* in 1719 and again by William Blake in 1791. European-American folk artists carried the tradition with cultural instinct, and popular American copyists learned the tradition more formally. Americans, like Europeans, were quick to sense the spiritual line in the "story line" of visual art, and with the help of men like Coleridge and Swedenborg, Edwards and Emerson, the ages and the continents were mystically and morally tied together.

The American experience was seen by the earliest settlers in Old Testament terms as "a pilgrimage," "a journey across the waters and through the land" to the New Jerusalem. This pilgrimage, this spiritual and actual journey, was a major foreshadowing event, a redemptive act that linked God's settlers — Adam and Eve leaving Paradise, Noah in the Flood, Jonah in the leviathan, Moses through the Red Sea, the pilgrims on the road to Emmaus — to America's settlers. Leaving home to begin again, finding the promised land held for them by God, became a theme as American as it was ancient and as current as it was eternal. As Nathanael Emmons, a conservative theologian of the early American republic, wrote, "God's taking our fathers from their native country, and bringing them . . . to this then dreary wilderness, was practically setting them apart for himself and making them his peculiar people." The hardships of the long voyage were no more than the purification of their own souls, and God's hand was in every defeat as well as in each victory. Redemption was ongoing; the ocean that baptized its travelers would reappear many times in symbol to purify the nation again.

The journey over land, like the voyage on the sea, was also a redemptive effort. God's light shone on the Prodigal Son after he wended his way into sin and out again. With concrete visual imagery relating to details of the New Testament parable, American watercolors of the Prodigal express the joy of forgiveness, of new life, of final union, and of being home again (see pp. 115-117). It was as if the 19th-century pages had been turned back to the 17th, and Benjamin Keach were relating the parable to St. Paul welcoming sinners back to the Church. Needlework pictures of the Queen of Sheba traveling to see Solomon (see p. 78), often depicting a castle on her side and a church on his, also conjured visions of such spiritual union — a heathen bride coming to wed the New Spirit. In one such needlework picture, a mica window on the Gothic church, shiny and reflective, suggests the illuminating grace of the New Law, windows (like the sun) providing a traditional symbol of divine light or of the Spirit. (Although some artists — copyists following the best tradition of their times — might have chosen emblems, motifs, and materials with a less than conscious awareness of literal or typological meaning, every choice — in art as in life — is born of an inner direction, has purpose, and shows some level of personal responsibility and cognizance.)

The biblical God provided a way out for the sinner — evil could be resolved in redemption. And God provided justice for the stubborn sinner as well. Justice was resolved in revenge. Biblical characters were seen as divine instruments,

and their cruelties in war were sanctioned under the guise of justice. Judith, who in the Apocrypha exemplified God's vindictiveness by beheading the enemy, was a popular figure with 17th-century artists (see p. 84). She was a political woman, who, like Esther (see p. 81), shouldered tribal revenge and symbolized a corporate or community movement against the mysterious power of evil in the world. She was understood, like the Fall, to be useful to God in bringing man to his knees. Such vengeance was not unknown in Puritan America, where the hanging of heretics was prompted by the same fervent impulse. A step in a more civilized direction was taken slowly by American Protestants as they relinquished their angers to God, reminded by their reading of Keach and others like him to let the divinity be responsible for punishment: let God curse the enemy, the heretic.

As more inward direction of prayer replaced retaliation, as charity replaced coercion, and as womanly ways of the heart took over the dominion of law, 19th-century progress in salvation became more domestic, more tender, and more forgiving. The orthodox view of grace as a gift relaxed to permit human efforts to complement God's will. Consequently, on the walls in Christian homes, pictures of such husbands and wives as Ruth and Boaz (see p. 74), Esther and Ahasuerus (see p. 31), Mary and Joseph (see p. 111), pictures of such mothers and babies as Jochebed and Moses, Hagar and Ishmael (see p. 52), Mary and Jesus (see p. 88) took precedence over scenes of war and beheadings. Depictions of the Crucifixion, the beast of the Apocalypse, and the Sacrifical Lamb continued in the repertoire of folk artists working in the rural European tradition, but the popular educated taste had mellowed the message.

The educated English-American woman began late in the 18th century to produce a new style of biblical picture. With the power of a large middle class behind them and the encouragement of the church, women themselves grew more vital, more equal, and more expressive in the world of religion, arts, and letters. By the 1800s, four-fifths of the middle-class readers in America were women. And it was from books again — illustrated religious, emblematic, and historical works as well as the current production of sacred dramas and sentimental novels from Germany, England, and America — that she drew inspiration and copied her designs. She was part of a larger artistic and literary uplift of the spirit, revelatory in character and inspired by the English romantic fusion of poetry, painting, and prophecy. The inspirations of West, Blake, Coleridge, Turner, Swedenborg, and Wesley moved the cultured heart of Europe and America in the direction of a new Christianity, a more mystical union of matter and spirit reminiscent of primitive religion everywhere.

If the 17th century had spiritualized commerce, trade, and literature, draining off the base elements of materialism from work's higher purposes, the 18th century spiritualized emotion, draining away the earthy sensuality from evangelical religion and from the new angels of the Lord. Handmaiden to the minister and pure as the country air in which she was ideally educated, the American woman — propagandized by the teacher, the popular press, and the popular painter — became a disembodied spirit, a root and country vine on which the nation grew.

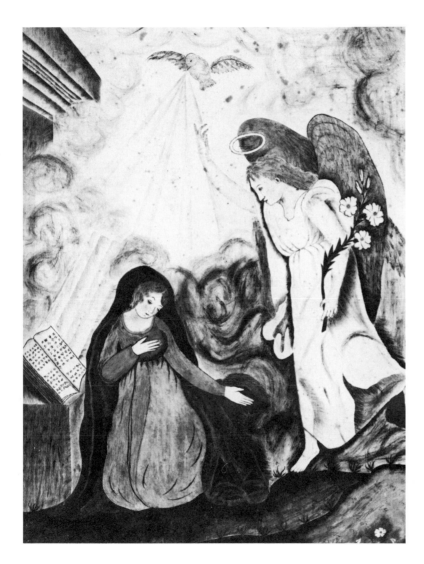

The Annunciation, artist unknown, probably Pennsylvania, paint on velvet, 19th century, 26½ x 20 inches, Sotheby Parke Bernet, Inc.

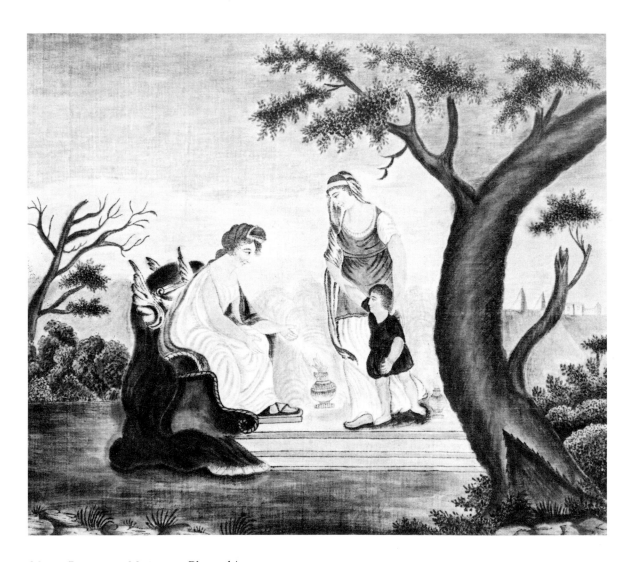

Moses Presenting Miriam to Pharaoh's Daughter, Sarah Wilkinson, Boston, paint on velvet, c. 1830, 15 x 19 inches, Sotheby Parke Bernet, Inc.

The reverence for women had small beginnings in America with the remarkable Puritan Cotton Mather, who had proclaimed in 1692 that there were far more godly women in the world than godly men. As Mather analyzed it, women were born to natural piety because of their suffering in childbirth and domination by men. Continuing a warm appreciation for female devotedness, Jonathan Edwards — 18th-century minister, theologian, and, in some ways, precursor of both Evangelicalism and Transcendentalism — perceived his wife's religious experience as the prototype for all proper conversions — devoted and bowing much like the famous Stothard engraving of Ruth marrying Boaz that was copied on popular American painted velvets (see p. 74). As the emphasis on religion shifted generally in the Protestant era from intellectual dedication to devotions of the heart, the race of women — sisters, wives, and mothers — coalesced into one throbbing religious symbol. To Horace Bushnell and his contemporaries, women were as William Blake had painted them — God's perfect idea, "an angel of help" glimmering mysteriously, inconspicuously, and with power, like the morning stars before the great sun. In "giving herself to a man in his weakness, to make him strong; to enter into the hard battle of his life and bear the brunt of it with him," women were, in a peculiar way, no longer human, no longer the symbol of evil, no longer a vindictive Judith — in essence, no longer the embodiment of medieval sin. They had been made over in the romantic tradition of Blake who had extolled the woman of mystical sense and drama. Blake, with Swedenborg, Emerson, and others, helped to change the definition of spirituality from intelligence to innocence, from strength to tenderness.

Home, once a center for trades and crafts, became as it were a 19th-century sanctuary. Craftsmen and merchants moved into town, leaving the home as a refuge away from commercial enterprise. The house became a visible symbol of a blessed state, the door or simple arcade — like Solomon's tent — a reference to heaven. In 17th-century pictures of Abraham's two families, his blessed wife Sarah stood inside her holy household tent while Sarah's maid Hagar, who bore Abraham's first son, Ishmael, was turned away unprotected. The same scene in the 19th century again blessed Sarah by placing her at the door of an early American cottage (see p. 53).

Marriage, like home, was part of the spiritualizing process in which the natural meaning of God's hierarchy continued. The domestic middle-class woman, still part of the ancient unequal covenant between the sexes, found glory in submitting to her husband just as church members were glorified by submitting to God. With the encouragement of ministers, many pious and educated women withdrew from the world of commerce, politics, and social fashion into a monastic home cocoon, where, isolated, they evolved their own form of power — cultivating family innocence and nurturing the reborn.

Following marriage, motherhood was woman's specialized domestic project in salvation. The breeding of leaders and rulers was a "princely" job, as Bushnell described it, with all the powers of nature, but none of ambition, and

with the forgetfulness of self which, too, was a "princely" virtue. Motherhood, according to Bushnell's theory of "Christian Nurture," turned every "good" mother into a domestic Virgin and every child into a prospective saint.

The death of children was woman's greatest trial and woman's greatest test of faith. Self-denial and sacrifice were feelings relived and understood in the pictures and dramas of Jephthah's daughter that became increasingly popular in the early 19th century (see pp. 67-68). Sacrificing herself willingly to fulfill her father's promise to God, the daughter — called Elizabeth in one closet drama of the day, but unnamed in the biblical story itself — demonstrated personal faith and loyalty to a covenant familiar in medieval as well as in romantic times and to an ancient appreciation for the community over its individuals. Replayed so soon after the great American war for individual rights, it spoke a heightened concern for American unity, a tightening and a cleansing of family and nation.

The middle-class American young lady was encouraged by her schoolmasters to demonstrate strong virtuous feelings towards her teachers, parents, and friends, and to express her pious sentiments in art. She benefitted from such headmistresses of great emotion as Susannah Rowson, author of the popular novel *Charlotte Temple* (1791), and Sarah Pierce, herself an amateur writer of sacred plays, and from such minister-masters as Joseph Emerson, Lyman Beecher, and Timothy Dwight. In the opening decades of the 19th century, it was common to find paintings of pairs of women dedicated to marriage as were Ruth and Naomi (see p. 73), or of virgins languishing at an altar bearing such inscriptions as "Sacred to Friendship." The female model, which had heretofore been the Holy Mother, had become blurred and tentative in the Protestant world. Teacher and student diaries from Miss Pierce's school in Litchfield, Connecticut, demonstrate a persistent belief that the saintly way could be inspired in girls by providing proper and early guidance in reading the "Sacred and profane history of the heroes and Christians who rose above the pleasures of animal nature." Stories of the biblical Deborah and Judith were read to inspire courage and to emphasize the greater influence of women in the world than of men through their roles as wives and mothers. And peace with God came through being a pious parent, Miss Pierce and her contemporaries maintained, motherhood being likened to the ark that saved Noah. In a pragmatic and sentimental interpretation of Genesis typical of the day, man, as ordered by God, tilled the soil of the material world, but woman, whose role was clearly ordained as part of the divine plan, planted and nourished the moral, spiritual, and national character in children.

Like Sarah Pierce, the English writer Hannah More, whose works were immensely popular and frequently reprinted in 19th-century America, put her respected stamp of chaste femininity on women. When writing, she tailored biblical facts and compositional purity to suit her own brand of moral instruction. Her *Sacred Dramas* (1798), in particular, visibly demonstrate how biblical stories were rewritten with literary license to illustrate contemporary moral concern for innocence, youthful heroes, first exploits, simple morals, and uncomplicated polar themes. She preferred for her subjects

the haze of innocence that emanated from the countryside, and young shepherds like David, the humble "unwarriors" God chose as kings. Like other contemporary artists, she preferred to work with themes from the Old Testament that cast light on the New — David and Goliath, Moses in the bulrushes, Belshazzar's feast, and Daniel with Darius. She portrayed women in the Moses story as universal characters of domesticity and charity — not merely the mother and sister of Moses, "God's peculiar people," but also Pharaoh's daughter, a "pagan" who saved Moses. Hannah More looked for virtues, as she put it, that were "not only admirable, but imitable, and within reach of every reader." Her popularity, and that of her distaff contemporaries, helps to explain the almost ubiquitous presence of the finding of Moses as a universal theme of 19th-century art (see p. 61).

People in the 19th century worried about the loss of the simple agricultural "good" life of such classical and biblical heroes as Cincinnatus, David, and Jesus. The "good" life in the young republic was threatened by the continued quest for individual rights, which, paradoxically, weakened the primacy of community, and by the parallel quest for material riches and the subsequent growth of "evil" cities. The innocent ways of Americans were dwindling, while the wish for innocence accelerated.

Cain was the symbolic father of the cities, and trade in 19th-century prints was frequently represented as a harlot. Merchants, manufactories, and money, while improving the environment of Everyman, fitted into a larger history of evil possibilities — luxury, laziness, waste, wantonnes, and pride. Popular artists, consequently, were preoccupied with the killing of brothers, as in the story of Cain and Abel (see pp. 41-43). The almost overwhelming strength of the story lay in the supernatural powers of evil and good beyond the imaginings of man: Evil, as well as goodness, could be an instrument of God and loomed larger than man himself, making him not a criminal but a victim. A similar atmosphere of evil is reflected in contemporary pictures of Belshazzar's feast painted by such eminent artists as Benjamin West and Washington Alston and then copied by engraver A. B. Walter and the American artist Jenny Snow after the work of John Martin (see p. 83). In these "epic" pictures, lightning strikes, snakes undulate and coil, and mammoth architecture dwarfs the feasters, making these scriptural panoramas reminiscent of the "moral" biblical epics of Hollywood's D. W. Griffith and Cecil B. De Mille, both possessing roots deeply set in American Victorianism. The scenes resemble Martin's *Palace of Pandemonium,* itself based on John Milton's description of Hell in *Paradise Lost*: "a Fabrick Huge...like a Temple [with] Doric pillars...[and] bossy Sculpture."

Sin fascinated the popular American reading public. Home libraries, school reading lists, and popular magazines referred their readers to illustrated stories of "Eve and the Serpent," "Temptation," "The Fall," and "the Expulsion." Inexpensive reprints of *Paradise Lost,* illustrated by Richard Westall and John Martin, were said by publisher Pro-

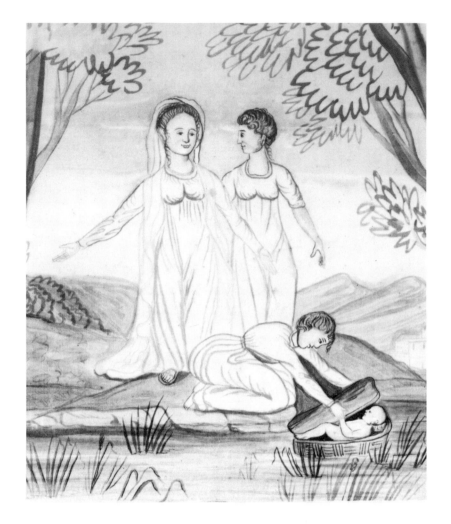

Moses in the Bulrushes, artist unknown, probably American, watercolor on silk, c. 1810, 21⅝ x 17⅝ inches, Abby Aldrich Rockefeller Folk Art Center, Williamsburg, Virginia.

The Peaceable Kingdom, from *A View of the Expected Christian Millenium,* by Josiah Priest (Albany, 1878), Winterthur Museum Libraries.

wett to have sold better in the United States than in Britain. Their illustrations from the *Imperial Family Bible* and *Illustrations of the Bible* also flooded the American market. Freely imitating these and other sources, popular painters Edward Hicks (see p. 51) and Erastus Salisbury Field (see pp. 64-66, 70-71), lithographer Nathaniel Curier (see p. 34), and local schoolgirls found them very expressive vehicles for private musings on original sin — the disobedience of Eve, and Adam's conscious rejection of reason and of God in taking the apple and following his woman out of Paradise (see pp. 37-39). The popularity in America of Milton's great epic led directly to an outpouring of contemporary art on the Fall. Though early engravings of the Expulsion by Cheron, Medina, and Chaperon depicted Eve without the hand-on-head gesture of conscious pain, Swedenborg gave Eve the same credit as Adam for knowing what she had done. Consequently, the pictorial American Eve shared Adam's painful hand-head gesture (see p. 40), and in many pictures depicting the death of Abel, Eve was obviously in greater pain than Adam (see p. 43).

American men of letters rekindled the Augustinian spirit of the "happy sin," or what was also called the "fortunate Fall." It was the poison from which innocent honey grew, wrote Giles Fletcher in a 17th-century poem. Nathaniel Hawthorne, Herman Melville, and Oliver Wendell Holmes recreated fictional characters who developed spiritually from encounters with evil. Elsie Venner, in Holmes's story of the same name, inherited her evil from bad ancestors. She possessed a measure of sin, but, as her townspeople saw it, "it ain't her fault." Thus she had the 19th-century hope of unlearning things bad and growing into goodness. Almost all the biblical scenes in this book, no matter how "evil" the subject portrayed, contain the promise of redemption inherent in the sinful act itself.

Woman was America's figurative connection between sin and salvation. Half temptress and half angel, womankind consisted of equal parts of Eve and of Mary, both sides of the same coin as were the Fall and Redemption and the Old Testament and the New. The two-sided female symbol, passed down in form and thought from Suger's genius, Ripa's iconography, Wither's and Quarles's emblems, and Montfaucon's drawings, gave the 19th century an unselfconscious way of observing and understanding sin and at the same time rejuvenated an interest in the Virgin not seen since before the Reformation. Woman could smile, and she could grieve. She was of flesh, and she was of the spirit. Like fire, she could serve her master powerfully; like a star which shares the evil of night, she also reflected the good light of day. Whether Eve in the garden or stars in the sky, the female symbol was usually positioned to the left of God or of God's tree (see, for example, p. 39).

The stars in biblical metaphor are about as far as man can go in the heavens. Lucifer, trying to go higher, fell from heaven altogether, and Job, baffled and arrogant, discovered his own limitations in the miracle-filled atmosphere: "The morning stars sang together, and all the sons of God shouted for joy" (Job 38:7). What hovered above the stars

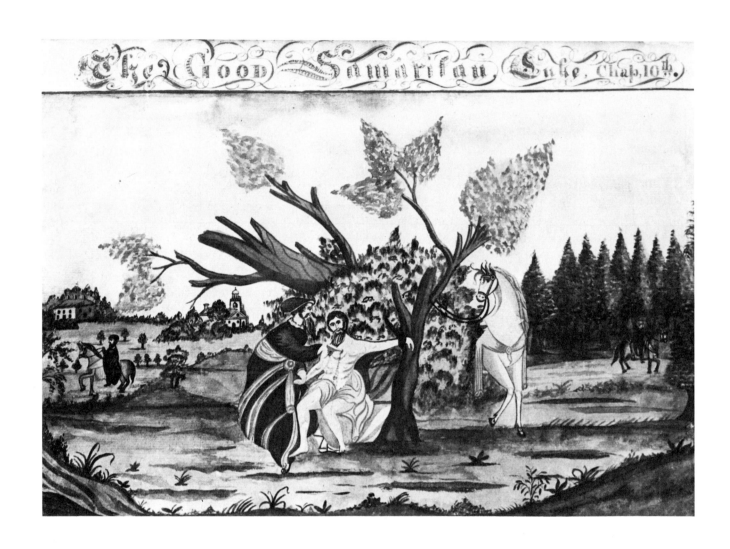

The Good Samaritan, attributed to John Landis, Pennsylvania, watercolor on paper, c. 1800, Private collection.

belonged to no man. Erastus Salisbury Field, in what seems at first to be an incongruent Garden of Eden — all tropical and fertile, yet surrounded by barren, rocky crags — perceived that heaven held Paradise and Hell, order and chaos, solitude and turmoil, Lucifer and God in a kind of harmony where beginning meets end (see p. 49). America, in the dreams of settlers, was just such a garden growing from the roots of schism and mutual intolerance until, as the early 19th-century popular historian Leonard Woolsey Bacon reasoned, American unity became very sweet. Incongruity advanced the American kingdom. Individuality advanced the sense of community. The simple gesture of one man for another, be he Solomon, the Prodigal's father, or the Good Samaritan, contained for all the seed of ancient Hebrew wisdom and the flower of New Testament truth and grace, the perfectability of human conduct and the reflection of heavenly bliss. Like spiritual men everywhere, Americans saw themselves in their biblical pictures as one note in the eternal melody, as one blade in the divine bed of grass, as one branch from "the root and the offspring of David, and the bright and morning star."*

The authors gratefully acknowledge the generous assistance given them by the following scholars, institutions, and friends: D. W. Robertson, Jr. and Emory Elliott of Princeton University; Charles Green of the Princeton University Library; Hugh T. Kerr and John M. Mulder of the Princeton Theological Seminary; Beatrix T. Rumford of the Abby Aldrich Rockefeller Folk Art Center; Isobel Beattie of the Victoria and Albert Museum; Charles F. Hummel, Frank H. Sommer, Sherry Fowble, and Karol A. Schmiegel of The Henry Francis du Pont Winterthur Museum; Beatrice B. Garvan of the Philadelphia Museum of Art; Lynn E. Springer and Louise Walker of The St. Louis Art Museum; Norman Rice, Louise Laplante, and Charlotte Wilcoxen of the Albany Institute of History and Art; Howell J. Heaney of The Free Library of Philadelphia; Jane C. Nylander of Old Sturbridge Village; C. R. Jones of the New York State Historical Association, Cooperstown; Walter E. Simmons, II, of Greenfield Village and the Henry Ford Museum; Loren Taylor of the National Gallery of Art; Roberta Deveno of the Museum of Fine Arts, Springfield, Massachusetts; Carol Steiro of the Museum of New Mexico; Philip H. Dunbar of The Connecticut Historical Society; Margaret J. Moody of the Shelburne Museum; Gumvor Vrctblak of Nordiska museet; William Stahl and Nancy Druckman of Sotheby Parke Bernet, Inc.; Lawrence A. Fleischman and Martha Fleischman of the Kennedy Galleries, Inc.; Richard A. Bourne of Richard A. Bourne Co., Inc.; staff members of the Metropolitan Museum, the Library of Congress, the Pennsylvania Historical and Museum Commission and William Penn Museum; Robert McNeil, the Walter E. Simmonses, the William B. Carnochans, the Walter L. Wolfs, Doris Dinger, Francis Matthews, Nicholas Schorsch, and Irvin G. Schorsch, Jr.

*Revelation 22:16

THE MORNING STARS SANG

Opposite: The puzzling scriptural motifs of sky, sun, clouds, garden, and the world itself have revealed God since the classical Golden Age. On the title page of the first gardening book in English, the Garden of Paradise on Earth is pictured at the moment just before the Fall as a collection of all "good things" — of flowers, herbs, roots, fruits, trees, shrubs, spiritually and materially useful to God's creatures Adam and Eve. Adam's function in Paradise, in fact, was "to till it and to keep it," thus making his story a suitable frontispiece for a 17th-century manual of gardening.

The Garden of Eden is an interior garden — that is, an allegorical garden of the soul rather than of the senses — planted with traditional symbols: palm trees of spiritual triumph, fruit trees of spiritual fertility, and grape vines of the spiritual Christ. The river and streams, symbolic of the cleansing spirit, flow through the iconographic landscape. Flowers, which include the carnation of love and the daisy of faith, grow everywhere. A bird, sometimes symbolic of the sexuality of the first man and woman after the Fall, perches in a branch of the tree which, like the ancient elm, supports the grape vine. Both tree and vine suggest the promise of the future redemption after the Fall. God — His Hebrew name emblazoned on the sun in a cloud — shines down from above. This illustration represents the unity of all life as it would have been understood in the 17th century — Nature growing in the Garden, in the body, and in the soul.

This historic frontispiece was reproduced with much commentary in an 1885 issue of the popular farm magazine *The American Agriculturist,* indicating its appeal to the ordinary farmer of the Victorian period. For another version of the Garden, see p. 49.

Before the Serpent Came, illustration from *Paradisi in Sole,* John Parkinson (London, 1656), Rare Book Room, Princeton University Library.

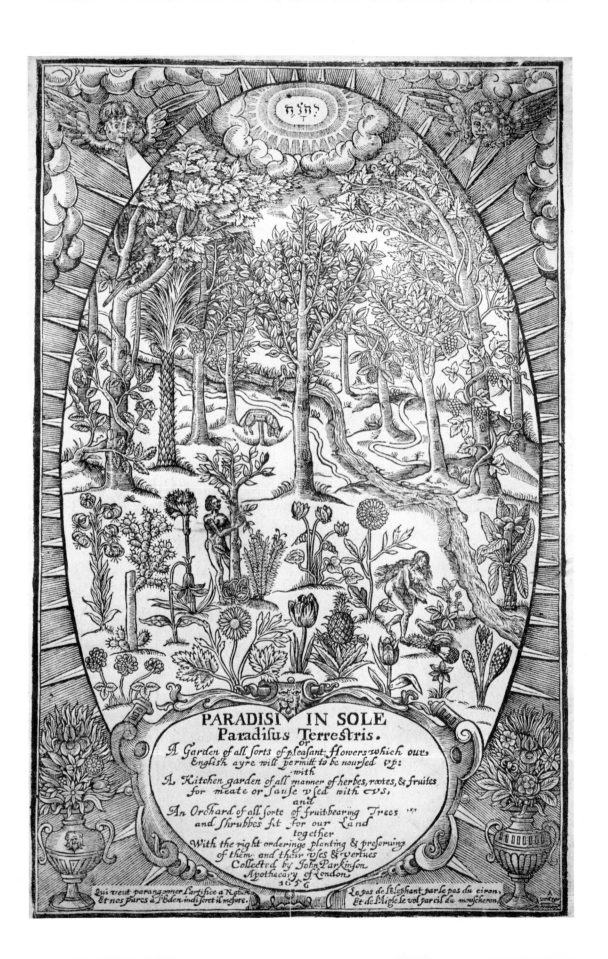

This American print captures with literalness and charm the words of Genesis 2:19. "And out of the ground the Lord God formed every beast of the field, and every fowl of the air; and brought them unto Adam to see what he would call them; and whatsoever Adam called every living creature, that was the name thereof."

Adam Naming the Creatures, N. Currier, American, hand-colored lithograph, 1847, 8¹⁄₁₆ x 12⁵⁄₈ inches, Library of Congress.

ITH. & PUB. BY N. CURRIER. Entered according to Act of Congress in the year 1847 by N. Currier, in the Clerk's office of the District Court of the Southern District of New-York. 152 NASSAU ST. COR OF SPRUCE N.Y.

ADAM NAMING THE CREATURES.

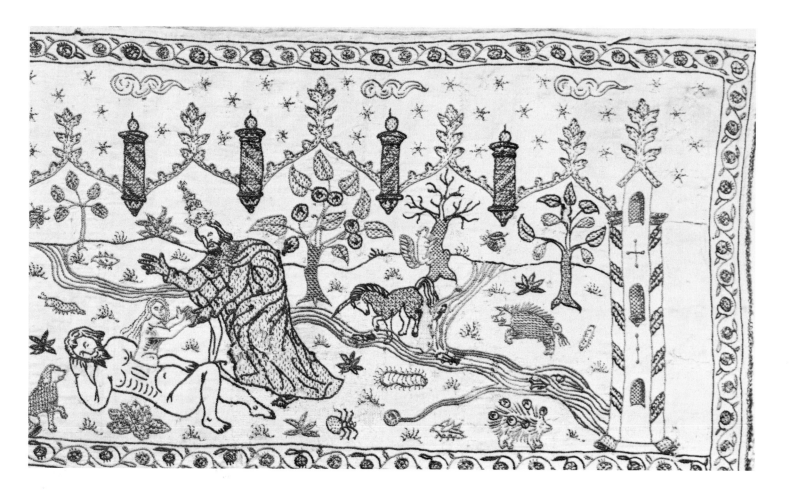

This fascinating scene foretells both the coming Fall and the future Redemption of man. Eve, a symbol of the knowledge of the visible world, is depicted rising, with the help of God, out of Adam's rib. The Garden remains an interior or spiritual garden surrounded by the symbolic wall, and in it continues to flow the regenerative waters of baptism. A unicorn, symbolic of purity in general and of female chastity in particular, puts its front hoofs in the stream. The porcupine, wild boar, caterpillar, and crawling bug are typical iconographic motifs of the presence of sin or, at least, of the material world to which Eve is symbolically connected. God is presented, as in early mystery plays, with enveloping robes and a three-tiered crown, material riches here denoting spiritual riches. Note the lamb (Jesus, or the "New Adam") on Adam's right, the promise, like the stream, of redemption.

The Creation of Eve, detail of pillow cover, artist unknown, English, silk, silver, gold on linen, early 17th century, 33 x 20½ inches, Victoria and Albert Museum.

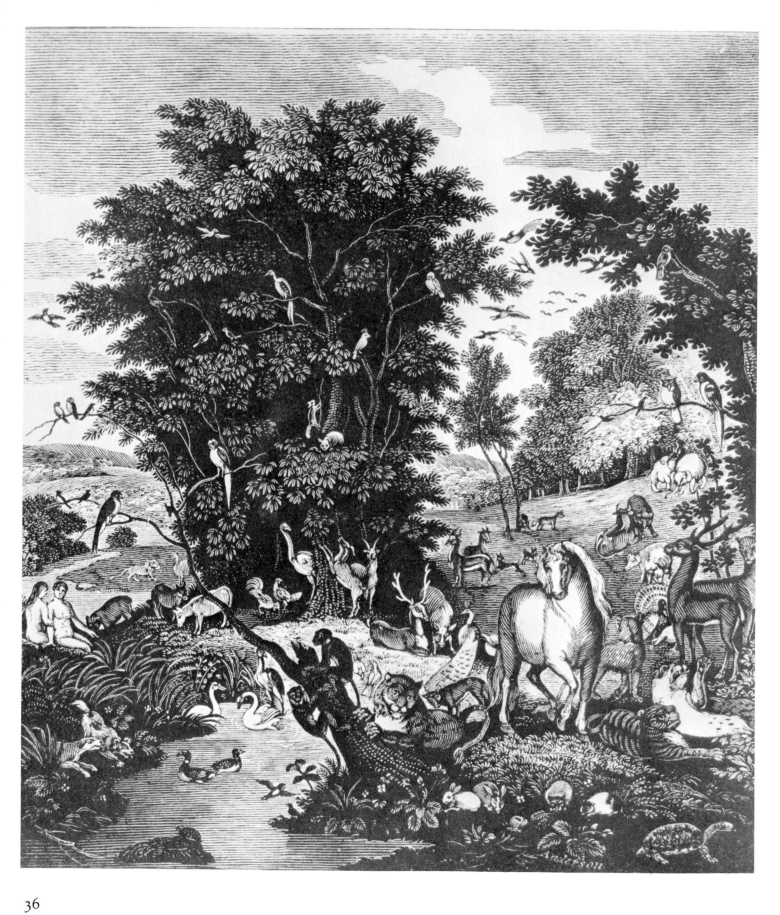

36

Even 19th-century Americans knew that an aspect of Eve's sin was sexual knowledge. Here winged creatures hurl leaden arrows, allegorical symbols of the death of the spirit, at the very moment that Eve reaches for the phallic serpent. These arrows, traditional symbols for centuries, were believed to pass through the eye to the heart and soul of lovers, victimizing them through their sense of sight. (Note, too, the birds, almost always present in scenes suggesting sexual sin.)

Eve and the Snake in the Garden, artist unknown, American, paper on paper cutout, 19th century, Sotheby Parke Bernet, Inc.

Opposite: The Creation, from *Works of Flavius Josephus* by George Maynard (New York, 1742), woodcut, Sinclair Hamilton Collection, Princeton University Library.

The story of original sin, committed in Eden by the first human couple, is a narrative frought with sexual meaning. In a symbolic landscape of fluttering birds and a lone squirrel — all centuries-old icons of sexual sin — the wily serpent beguiles a vulnerable Eve through promises of greatness. Adam, his hands outstretched in masculine uxoriousness, awaits his turn to eat the forbidden fruit. The couple is clothed, less from Pennsylvania-German prudishness than as a symbol of fallen grace. The carnations of love and the daisies of faith foreshadow the promise of the New Adam and man's salvation. The disembodied branch held by the bird is a symbol of the branch of the tree that Eve broke and signifies her guilt and shame.

Adam und Eva, artist unknown, probably Pennsylvania, Fraktur watercolor and ink on paper, c. 1790-1825, 7¾ x 9⅝ inches. The Henry Francis du Pont Winterthur Museum.

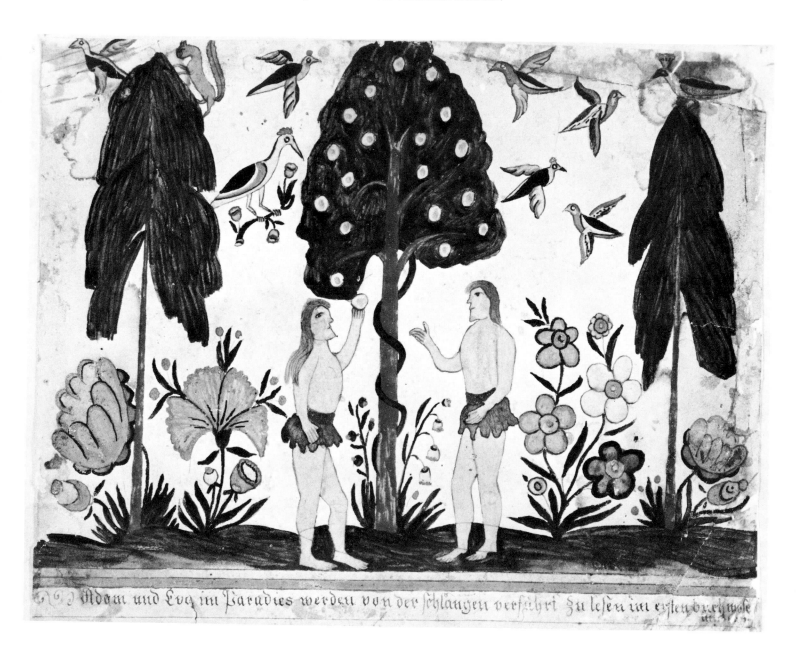

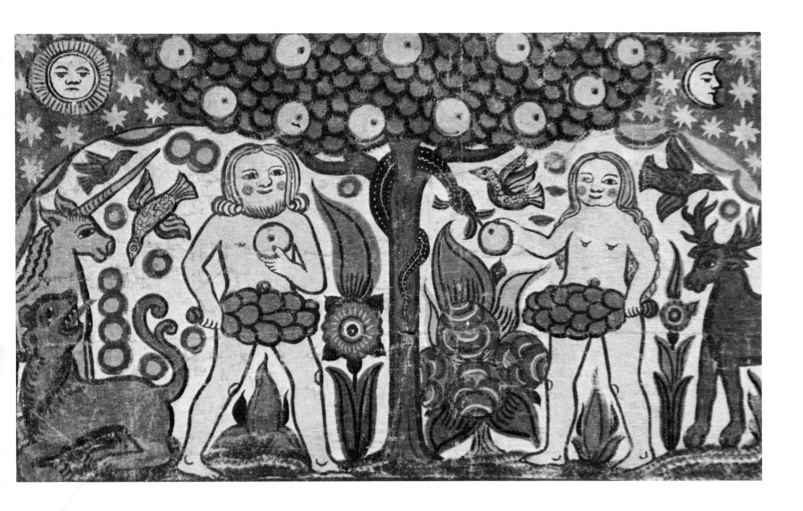

This 19th-century Swedish painted cloth is firmly within a centuries-old folk tradition, despite its relatively late date. A detail of a larger scene depicting Jesus's miracle at Cana, the work sets into opposition symbols of good and of evil to show the triumph of redemption over sin. Adam and Eve are accompanied by the spiritual unicorn, the hopeful stag, and the amorphous monster representing sins of the flesh. The stag or hart next to Eve is the animal which pants after God in Psalm 42:1 and is a symbol of the regenerated man. The sun, a common God motif, appears on the side of Adam; the moon and the stars, gathering a secondary reflective light, appear on the side of Eve.

Adam and Eve, detail from *Christ Changing Water to Wine*, Anders Palsson, Swedish, paint on linen, 19th century, The Metropolitan Museum of Art, Gift of Mr. and Mrs. William Maxwell Everts.

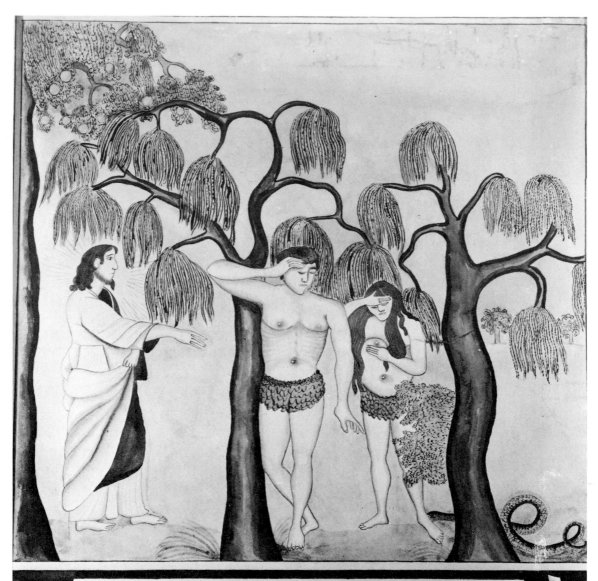

God in the person of Jesus expels Adam and Eve from Paradise. The willows of grief bow sorrowfully for them, replacing the tree of knowledge in the center of the Garden. Both Adam and Eve raise their hands to their heads, hiding their eyes in shame. The snake at Eve's heel recalls God's curse on the snake (enmity will bruise its head and it will bruise man's heel) and denotes the consequence of sin passed on to her unborn world. The pictorial images here represent as much what Genesis 3:8-24 implies as what it actually says. (See also p. 50.)

God's Call to Adam, artist unknown, American, watercolor on paper, c. 1800, 15¾ x 12¾ inches, Kennedy Galleries, Inc.

In the continuing drama of sin and the promise of redemption that is Genesis, what was disobedience in the father, Adam, has now developed into murder by his son Cain.

Cain and Abel, lithograph of Pendleton, from *Scripture Prints* by Mrs. Sherwood (New York, 1832), The Henry Francis du Pont Winterthur Museum, Joseph Downs Manuscript Collection.

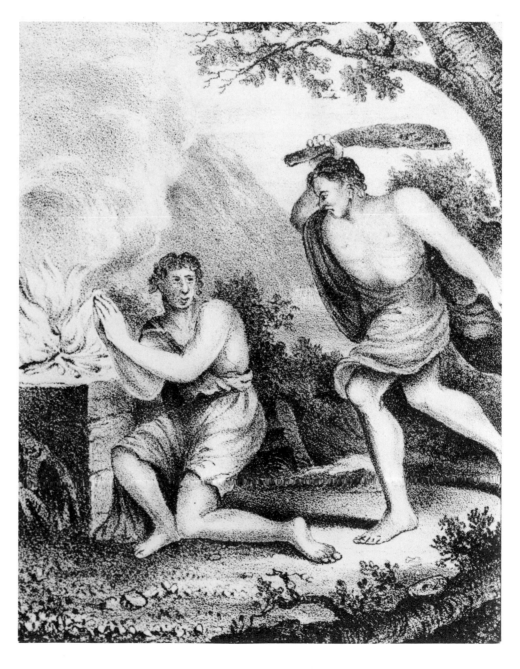

Opposite: The main figure in the *Death of Abel* is not Abel, but Eve. (A central figure for Blake, her sorrow was a popular subject for many Romantics.) Poised on her knees, arms imploringly outstretched, Eve incorporates all the grief and sacrifice implied in the loss of a great son. Joining her in mourning are Cain and Abel's wives and their children. The willow, of course, suggests grief and the rainbow overhead recalls the major theme of Genesis: the promise of God's covenant and the regeneration of man. Adam, too, has been afflicted, but he remains more calm, more rational, understanding clearly that "the wages of sin is death." Goodness and evil live side by side, brother to brother, husband to wife, mother to son.

The Death of Abel, Mrs. H. Weed, English or American, wool, silk, and paint on silk, c. 1830, 28 x 32½ inches, Abby Aldrich Rockefeller Folk Art Center, Williamsburg, Virginia.

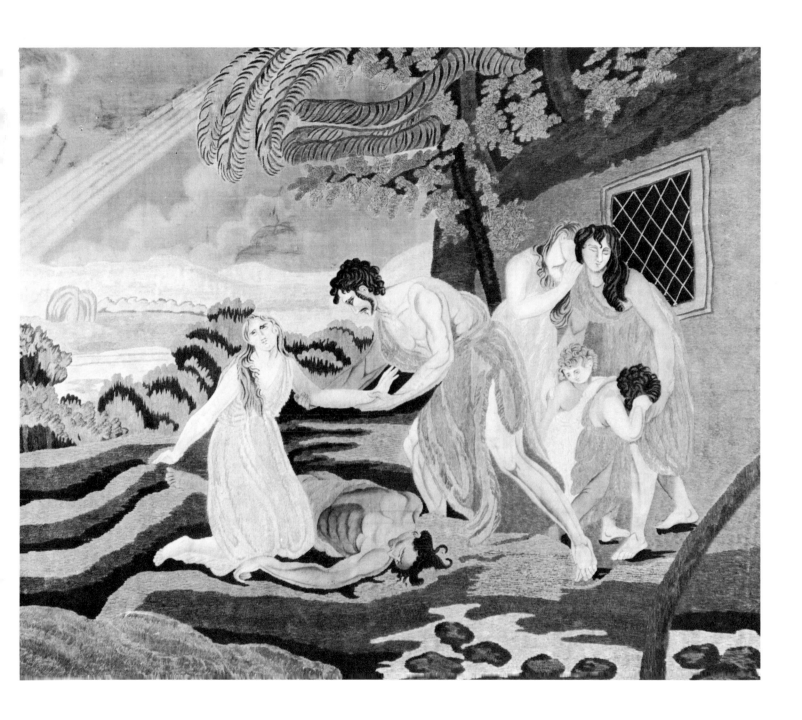

43

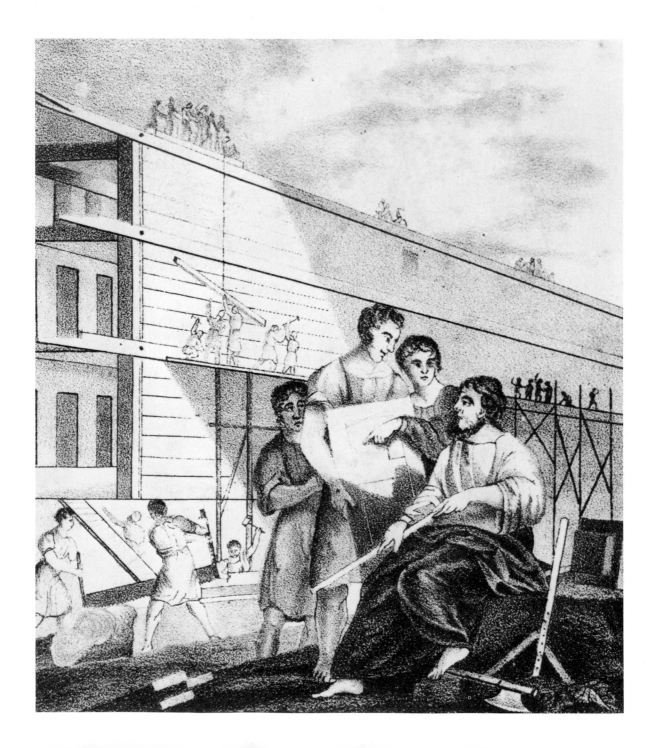

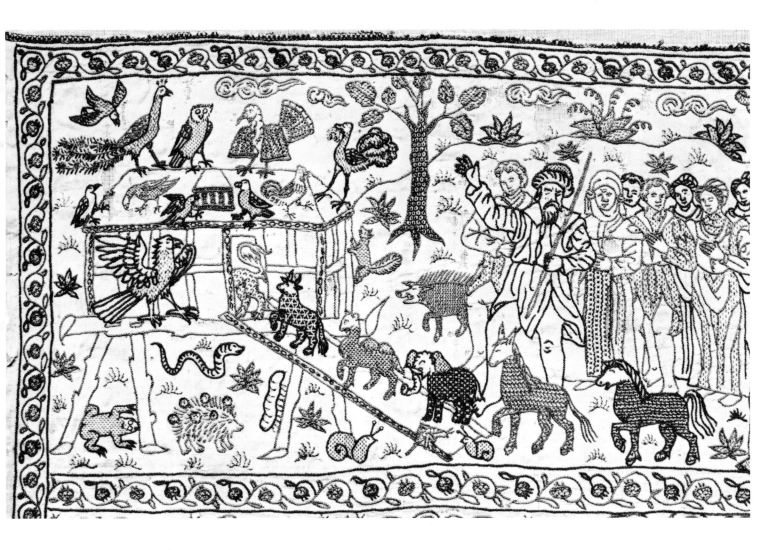

God has commanded Noah to take every type of creature aboard the Ark, the vain earthly creatures as well as the more spiritual ones. Noah stands with some importance as the only male with a hat and a staff. The furry squirrel climbs up the side of the Ark in much the same way as he climbs the tree in 'The Garden of Eden' and 'The Creation of Eve' illustrations, a sure sign that sin will not perish with the Flood. (For Edward Hicks's version of the same scene, see p. 51.)

Animals Entering the Ark, detail of pillow cover, artist unknown, English, silk, silver, gold on linen, early 17th century, 33 x 20½ inches, Victoria and Albert Museum.

Opposite: Charmingly literal in its attention to detail, this 19th-century American lithograph captures the massive dimensions of the Ark, dictated to Noah by God. The Bible nowhere mentions the scores of capenters and boatwrights that would have been required to build a vessel some 515 feet long and three-stories high.

Noah Building the Ark, lithograph of Pendleton, from *Scripture Prints* by Mrs. Sherwood (New York, 1832), The Henry Francis du Pont Winterthur Museum, Joseph Downs Manuscript Collection.

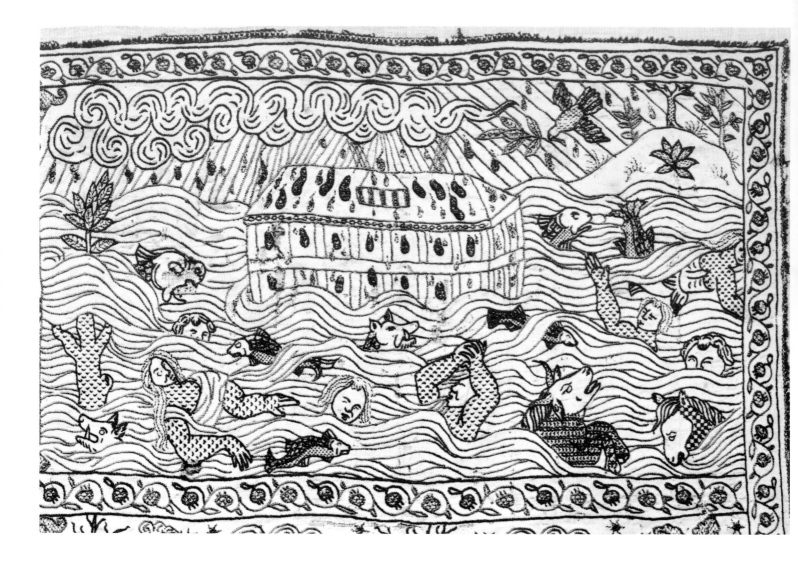

When the rains come, Noah and the spiritual elect remain dry, while the rest of the world — "the spirits in prison" — drown in the Flood. The dove, sent forth by Noah seven days after the rains cease, returns with an olive branch — an image of hope. In the best medieval tradition — stubbornly maintained in art at least through the 17th century — the 6½-month period between the Flood and the sighting of dry land is spanned in one artistic instant.

The Flood, detail of pillow cover, artist unknown, English, silk, silver, gold on linen, early 17th century, 33 x 20½ inches, Victoria and Albert Museum.

Opposite: Upon leaving the Ark for dry land, Noah and his family offer a sacrifice as thanks to the Lord. The rainbow — the sign of God's covenant with man — is a reminder that although the high purpose of Creation has been frustrated by man's improper use of his freedom, God will nevertheless accept man's natural predilection to evil and permit him to exist in an ordered universe that guarantees the necessities of life.

Noah Leaving the Ark, lithograph of Pendleton from *Scripture Prints* by Mrs. Sherwood (New York, 1832), The Henry Francis du Pont Winterthur Museum, Joseph Downs Manuscript Collection.

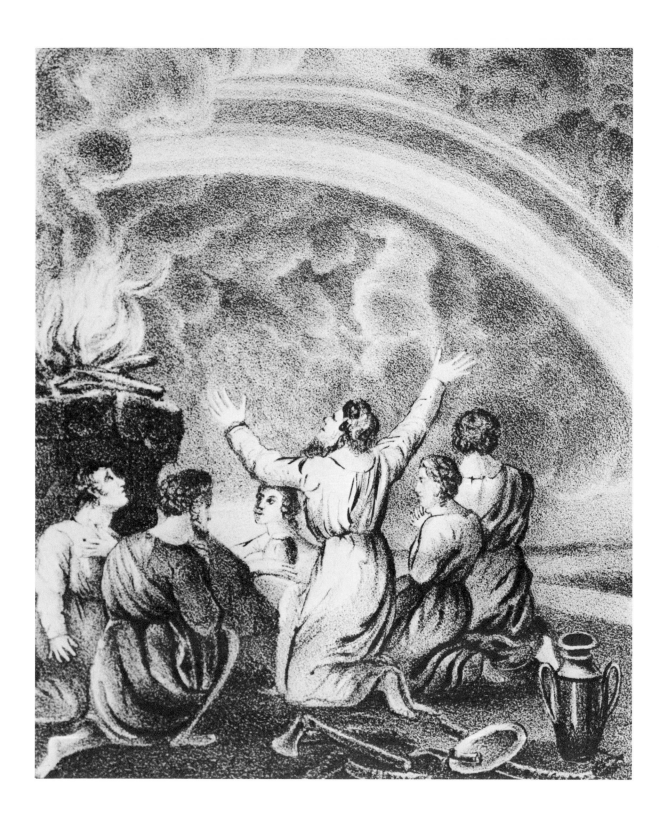

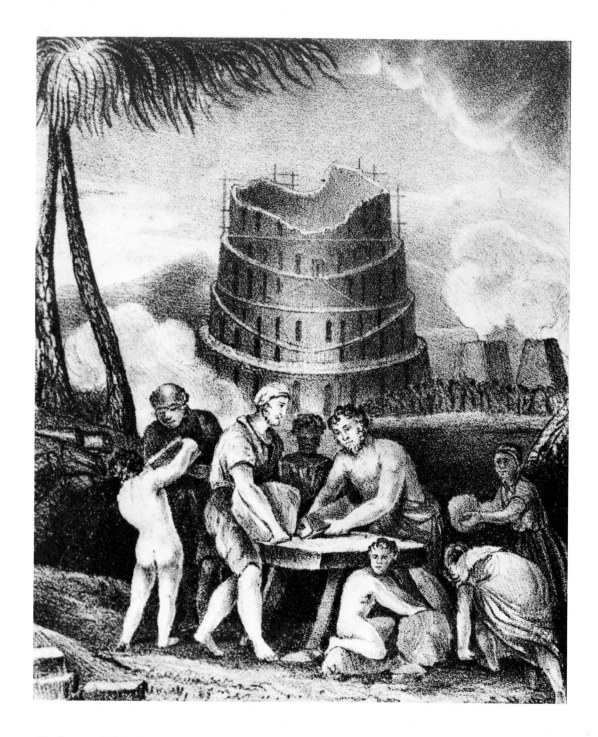

The famous Old Testament parable of man's arrogant pride, symbolized by the soaring Tower, is captured in this imaginative setting of Genesis 11:3-4. As a result of his pride, man lost his ability to understand anyone but himself.

The Tower of Babel, lithograph of Pendleton from *Scripture Prints* by Mrs. Sherwood (New York, 1832), The Henry Francis du Pont Winterthur Museum, Joseph Downs Manuscript Collection.

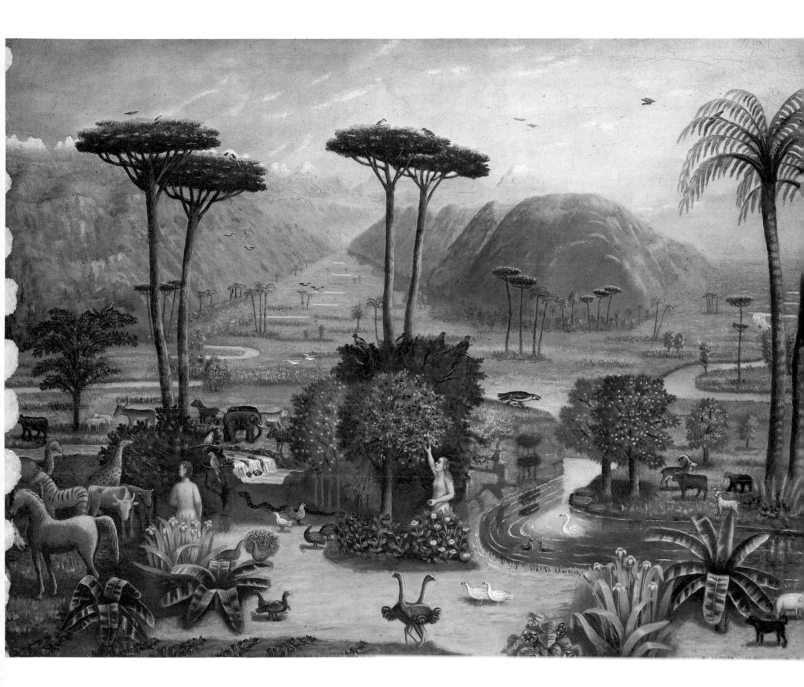

The Garden of Eden, Erastus Salisbury Field, American, c. 1860-1870, oil on canvas, 34¾ x 46 inches, Museum of Fine Arts, Boston, Massachusetts, M. and M. Karolik Collection.

The Fall of Man, artist unknown, American, 1809, watercolor and ink on paper, birth and baptismal certificate of George Manger, Abby Aldrich Rockefeller Folk Art Center, Williamsburg, Virginia.

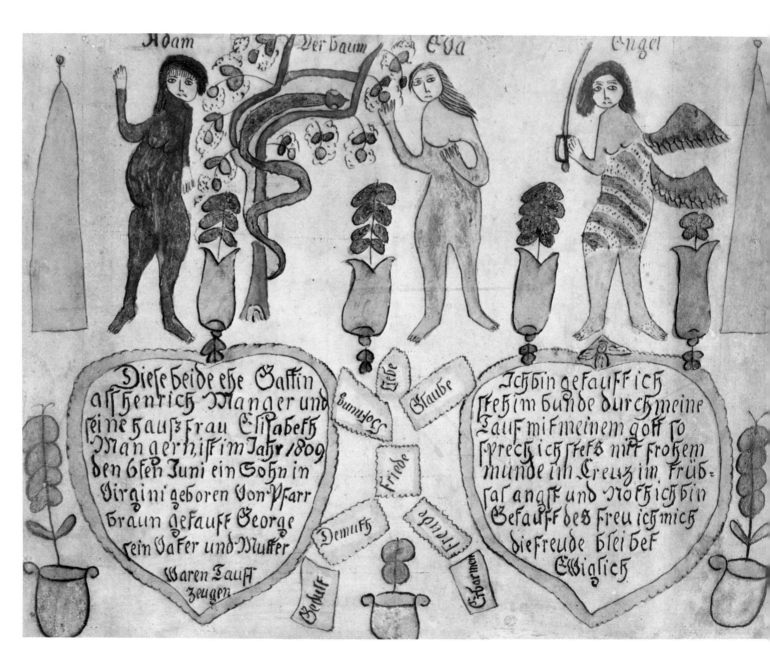

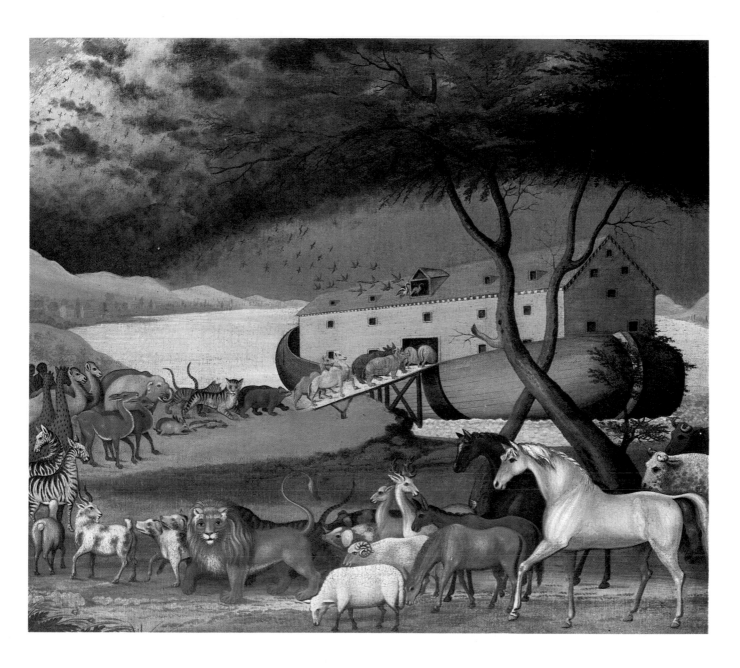

Noah's Ark, Edward Hicks, American, 1846, oil on canvas, 26½ x 36¼ inches, Philadelphia Museum of Art, Bequest of Lisa Norris Elkins.

Hagar and Ishmael in the Wilderness, artist unknown, American, c. 1825, watercolor, 16 x 19½ inches, Kennedy Galleries, Inc.

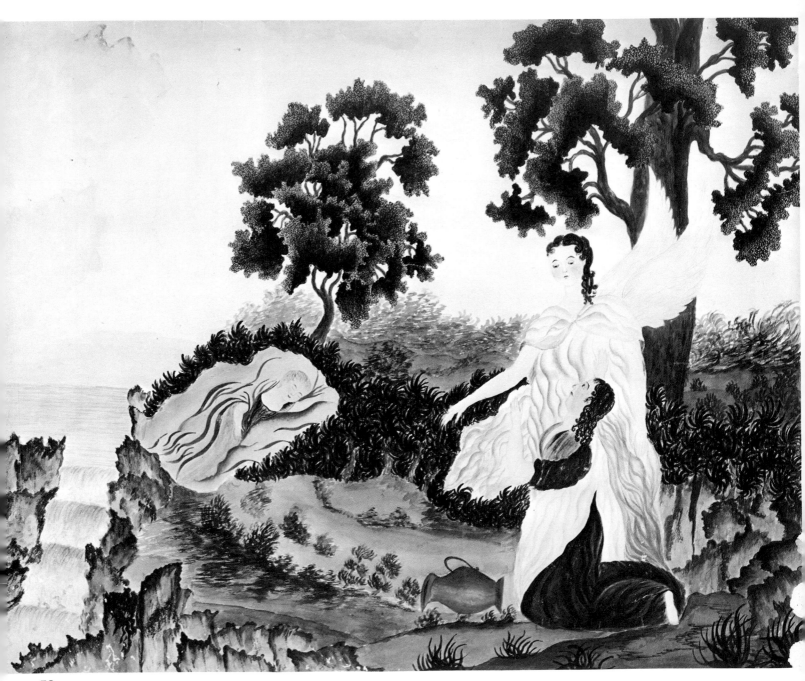

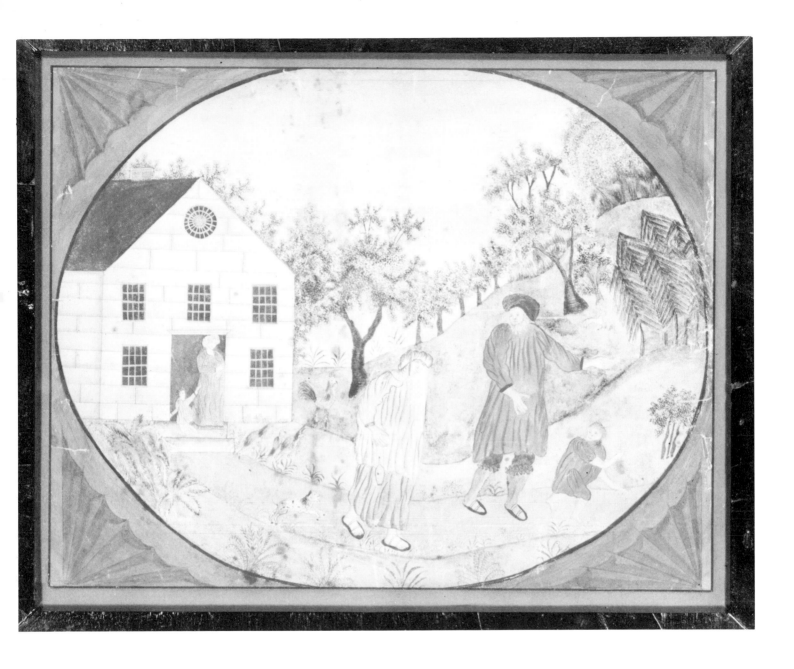

Hagar, Sarah's Egyptian maid, bore Abraham a son named Ishmael. He was not, like Isaac, the child of promise, but God blessed him in his condition and gave him a nation. For Abraham, who stands as a central figure in this watercolor, Ishmael was a reminder of his own failing faith. For the oppressed, Ishmael remains a victim of evil forces beyond his control. Another portion of the story — illustrated in color on p. 52 — captures the moment in which "the angel of God" shows Hagar water just in time to save the life of Ishmael, here portrayed as an infant in order to heighten the dramatic moment. (In the Biblical story, Ishmael is considerably older.)

Hagar and Ishmael, Emeline Dowe, New England, watercolor on paper, c. 1825, 13⅜ x 16⅜ inches, Private Collection.

Rebekah, a woman of good standing, is found by Abraham's servant whose mission is to provide a good bride for Isaac, the child of promise. Although other 19th-century Rebekahs had been painted in light linen robes and veils over the shoulder, simulating a "biblical" costume, this young lady wears a dress and bonnet of a more contemporary vintage. The two camels and the "menial" represent the riches sent by Abraham for the bride. The black slave is an interesting American addition and is not present in the Genesis story. Like other Old Testament subjects that prefigure the New, Rebekah is a model for the woman of Samaria (see p. 121).

Rebekah at the Well, artist unknown, American, watercolor on paper, c. 1810, 15¼ x 18½ inches, Abby Aldrich Rockefeller Folk Art Center, Williamsburg, Virginia.

Isaac, at 137 years of age, receives Jacob, the second of his twin sons, who comes disguised as the first born. In the manner of his brother Esau, a hunter of flesh, Jacob gives his father a dish of savory goat's meat which appears on the table in the painting. Isaac, in turn, gives him the blessed land of God's promise. Home is represented as a tent, a holy place, and Rebekah, Jacob's mother, sits near the bed, glad for the deception and, in her pleasure, resembling the Great Son's mother.

Isaac Blessing Jacob, artist unknown, possibly Albany, New York, oil on canvas, 17th century, 32 x 40 inches, Ricahrd A. Bourne Co., Inc.

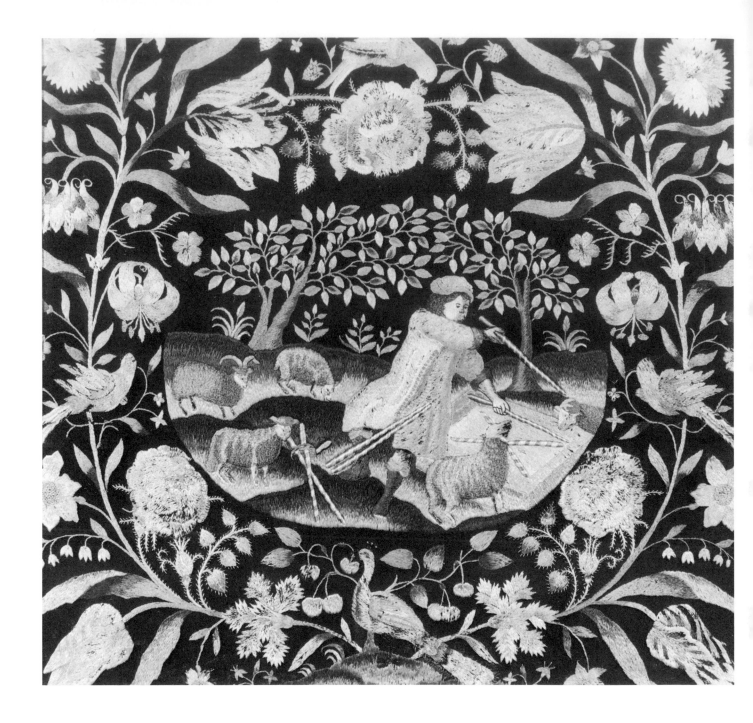

The strange story of Jacob the sheep breeder is one chapter in a complex narrative of intrigues and doublecrosses. Victimized by his father-in-law Laban's simple cunning, Jacob outwits him finally by his skill in animal husbandry and by his amassing of a fruitful flock, a certain sign of God's blessing. Pictured here is Jacob's miraculous use of "pilled" or stripped rods (Genesis 30:37-39) to bring about the conception of white lambs. Interestingly, the needlework artist has rendered the rods "striped," rather than "stripped" or peeled.

Jacob and the Spotted Sheep, artist unknown, probably Dutch, silk and wool on wool, 18 x 19½ inches, The St. Louis Art Museum.

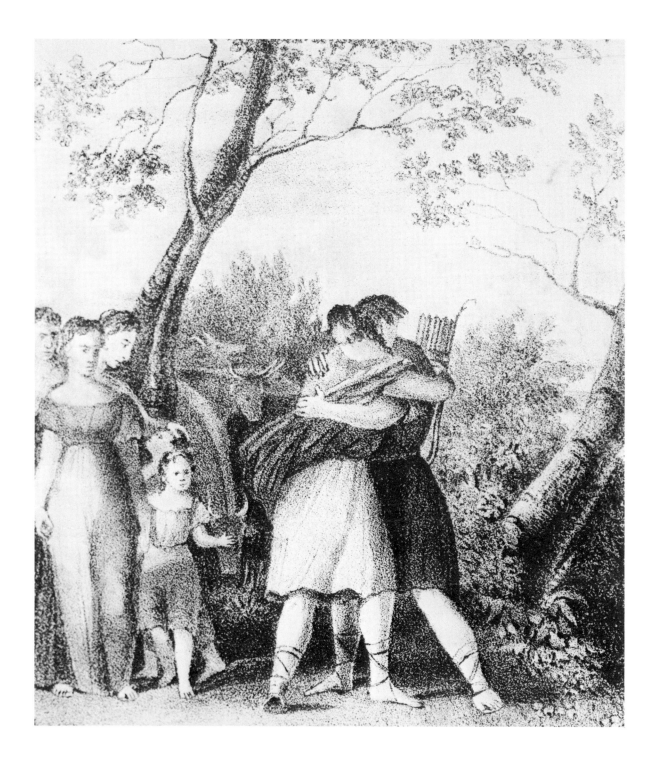

"And Esau ran to meet [Jacob], and embraced him, and fell on his neck and kissed him; and they wept" (Genesis 33:4).

Jacob Meeting Esau, lithograph of Pendleton from *Scripture Prints* by Mrs. Sherwood (New York, 1832), The Henry Francis du Pont Winterthur Museum, Joseph Downs Manuscript Collection.

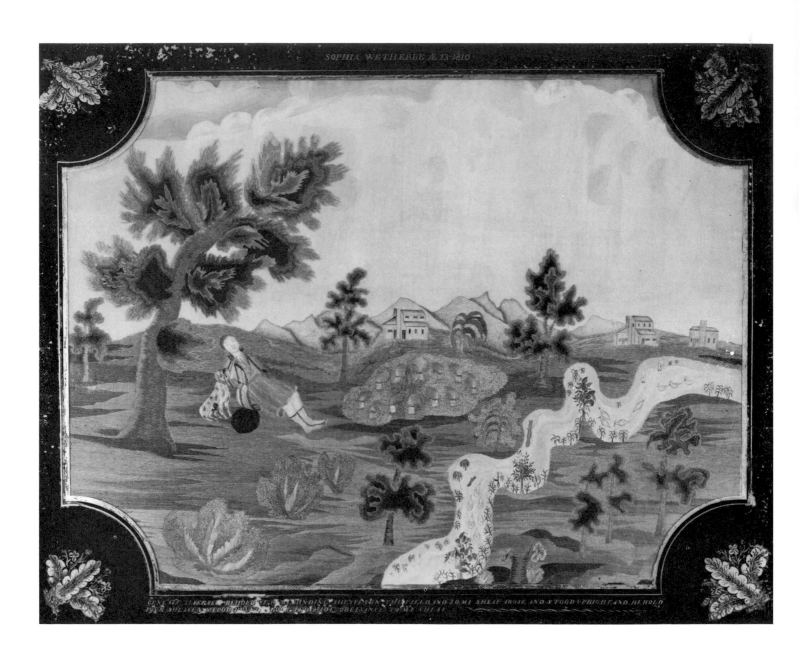

With his faithful dog — a wistful touch of the young artist — Joseph sits under a sacred tree on a hill, where God usually meets his elect, and dreams two dreams that grant him leadership over "the sun and the moon and the eleven stars" — his father, his mother, and his father's children (Genesis 37:9). The 19th-century landscape is of course delightfully anachronistic.

Joseph's Dream, Sophia Wetherby, American, silk and paint on satin, 1810, 25 x 32 inches, New York State Historical Association, Cooperstown.

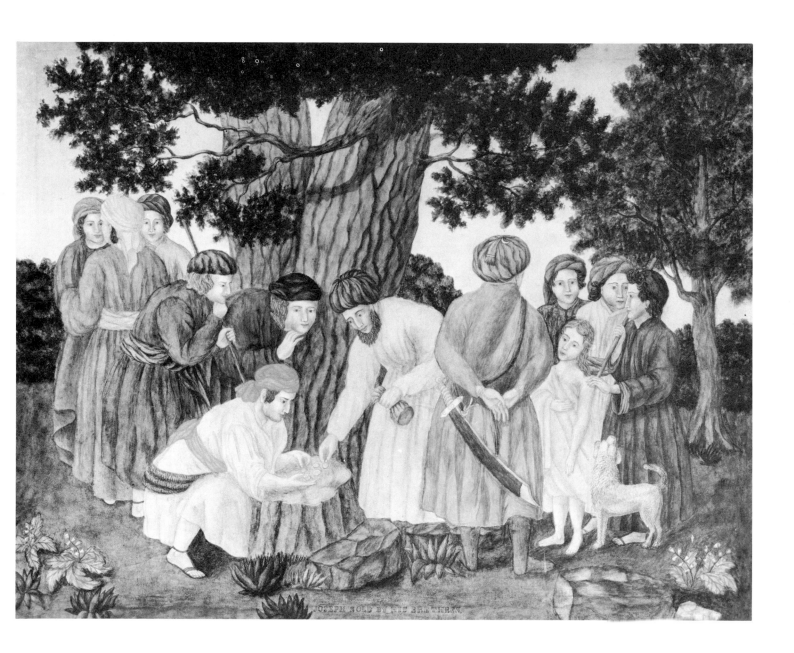

JOSEPH SOLD BY HIS BRETHREN.

Dressed in hats and robes, the brothers of Joseph sell him to merchant Ishmaelites for twenty pieces of silver. Joseph, standing among them, a very young man in bare feet and stripped of his coat of many colors, will one day forgive them. The picture popularizes a very common misreading of Scripture. Actually, Joseph is *not* sold by his brothers, but, after being left by them to die in an abandoned pit, he is found by Midianite merchants who sell him to the Ishmaelites (Genesis 38:25).

Joseph Sold by His Brethren, artist unknown, probably American, watercolor on paper, c. 1840, 26⅜ x 21⅝ inches, Abby Aldrich Rockefeller Folk Art Center, Williamsburg, Virginia.

Although this watercolor purports to illustrate only one verse (Genesis 41:8) of the story of Joseph, it captures many dramatic details of the entire chapter. Troubled by two mysterious dreams and by the inability of his magicians (*right*) to interpret them, Pharaoh is told by his chief butler (*left of center*) of a remarkable imprisoned Hebrew who excels in the interpretation of dreams. Joseph, who shaves his beard when he is summoned by Pharaoh, is carefully rendered here as a smooth-faced youth. Like the checkered floor on which he stands — long a Masonic symbol of good and evil — Joseph represents the good that comes from evil.

Joseph Interpreting Pharaoh's Dream, artist unknown, probably American, watercolor on paper, c. 1815, 9 x 11 inches, Abby Aldrich Rockefeller Folk Art Center, Williamsburg, Virginia.

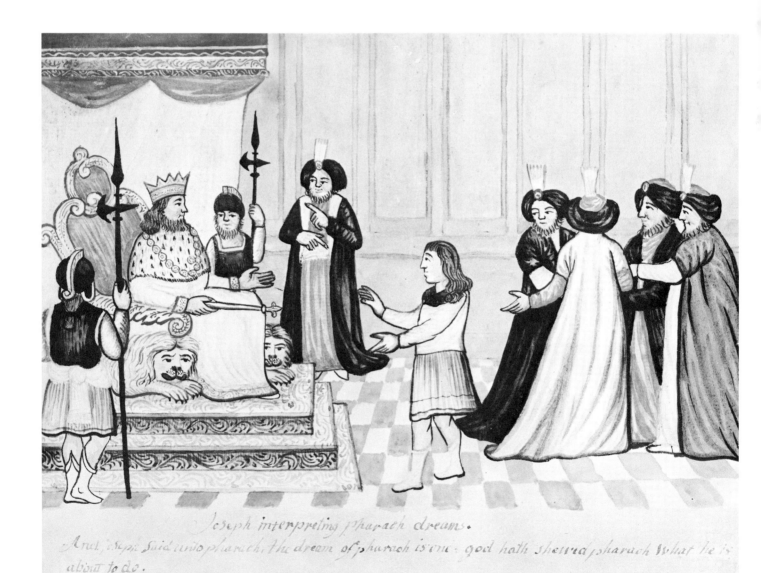

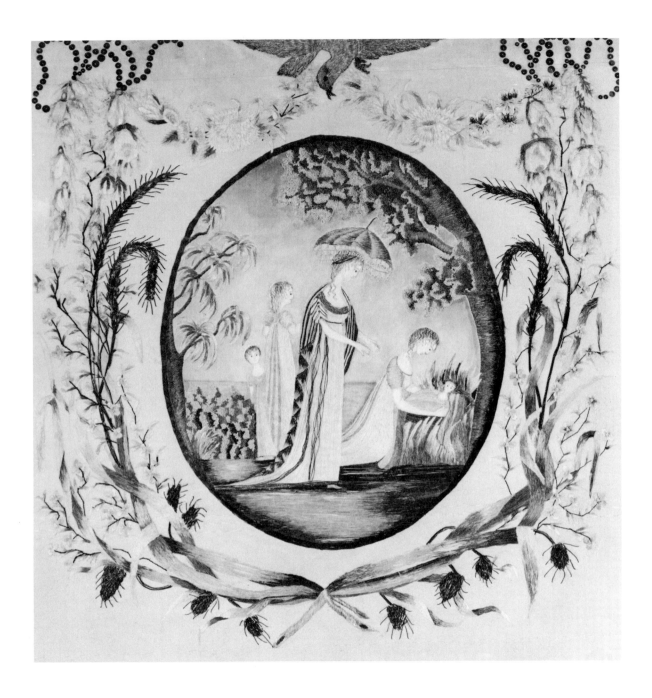

If womankind seems to loom large in this picture of the discovery of the babe Moses, making it a congenial subject for 19th-century American art, no wonder. For the story itself — from the refusal of the midwives to cooperate with Pharaoh, to the determination of Moses's mother to save her son from the massacre, to the irony of Pharaoh's daughter being involved in the divine plan — illustrates God's overruling providence which ensures that no power of evil can frustrate his good intentions. Rich in silk, and innocent in style, this fine example of American popular art is similar in motif with the 16th-century Cesare Ripa emblem of charity which enjoyed renewed popularity in the early 19th century. (See an earlier treatment of the same subject on p. 69.)

Moses in the Bulrushes, artist unknown, probably American, watercolor and silk on satin, c. 1800-1825, 19¾ x 18½ inches, Abby Aldrich Rockefeller Folk Art Center, Williamsburg, Virginia.

Opposite: This 18th-century sampler — fascinating in its schematic and symmetrical symbolism, yet perfectly conventional in its Christian meaning — presents Moses as the bringer of the Old Law and Jesus as the champion of the New. The representation of Moses and of Jesus on either side of the Commandments — though possibly uncommon to 20th-century eyes — is anything but surprising. Bible-reading Christians were long acquainted with the notion of the Old Testament lawgiver as a prefiguration of Christ. The Gospel of St. Matthew, in particular, goes to great length in drawing parallels between the two, especailly in the stories of Moses on Mt. Sinai and the similar story of Jesus delivering his Sermon on the Mount. That Moses and Jesus should stand on either end of the Decalogue is emphasized by the dark-stitched statement: "The Law was given by Moses. But grace and truth came by Jesus Christ." Moses brings the Law, God's universal, faithful, and predictable order to man; Grace and Truth, the spirit of forgiveness and inwardness, are offered by Jesus. Moses wears his corded cap like the pilgrims on the road to Emmaus (see p. 125). Jesus is bareheaded. Carnations of love hang over them both. Gabriel, the patron angel of the Hebrews, blows his trumpet for Moses; the butterfly of eternity flies next to Jesus. On either side of Adam and Eve sit the dark animals of the flesh that will be subdued by both the Old and New Laws; between them, and at the base of the Old Tree, stands a white lamb, symbolic of the New Tree — the true Cross.

The Ten Commandments, artist unknown, English or American, silk on linen, 18th century, 14 x 11 inches, Private Collection.

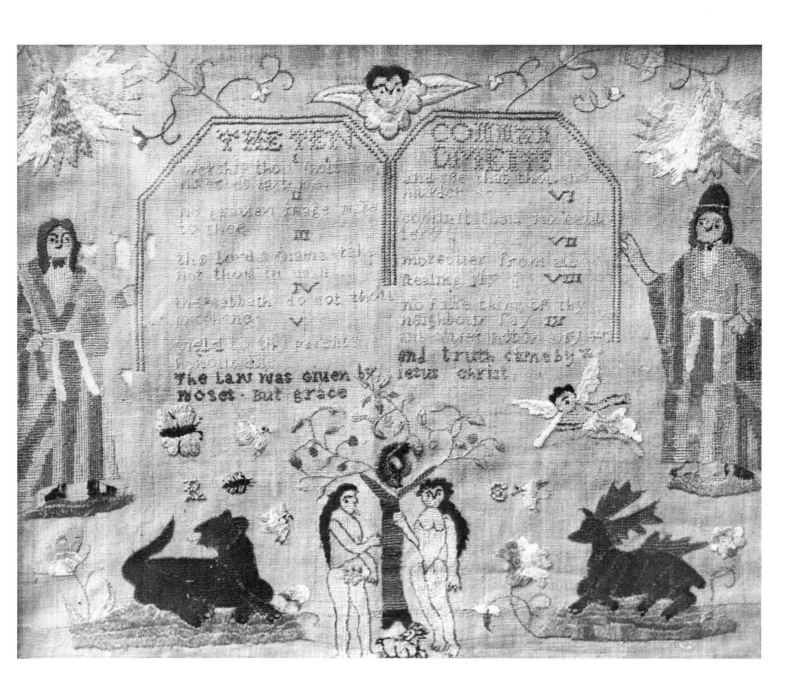

"And it came to pass, that at midnight the Lord smote all the firstborn in the land of Egypt; and there was a great cry in Egypt; for there was not a house where there was not one dead" (Exodus 12:29-30). A splendid palace and the luxury of costume no longer represent godly favor. Now, in the 19th century, material wealth, like technological progress, is read by many artists as an evil that also plagues mankind. This scene of cataclysmic grief as the wages of sin was copied directly from an engraving by John Martin published in *Fifty Illustrations of the Holy Scriptures* (1835) by Westall and Martin.

Death of the First Born, Erastus Salsibury Field, American, oil on canvas, c. 1880, 35 x 46 inches, The Metropolitan Museum of Art, gift of Edgar William and Bernice Chrysler Garbisch.

Like the previous painting, the *Burial* is a terrorizing sign of God's presence, a dramatic expression of his sovereignty and his order. The burial of Egyptians and the survival of their Hebrew slaves during the many plagues of flies, locusts, and disease reinforce the essential theme of Exodus: the survival of God's divine plan against all human opposition, an epic theme well suited to Field's almost operatic settings.

Burial of the First Born of Egypt, Erastus Salisbury Field, American, oil on canvas, c. 1880, 33¼ x 39¼ inches, Museum of Fine Arts, Springfield, Massachusetts, The Morgan Wesson Memorial Collection.

After the covenant with Noah, God promised never again to destroy a whole people. Instead, he tolerated wars and allowed men to destroy themselves. Erastus Salisbury Field, in an overpowering architectural statement, dwarfs the power of men as Pharaoh's army pursues the children of Israel to the Red Sea and to a miraculous death (see p. 71).

Pharaoh's Army Marching, Erastus Salisbury Field, American, oil on canvas, c. 1865-1880, 35 x 46½ inches, National Gallery of Art, Collection of Edgar William and Bernice Chrysler Garbisch.

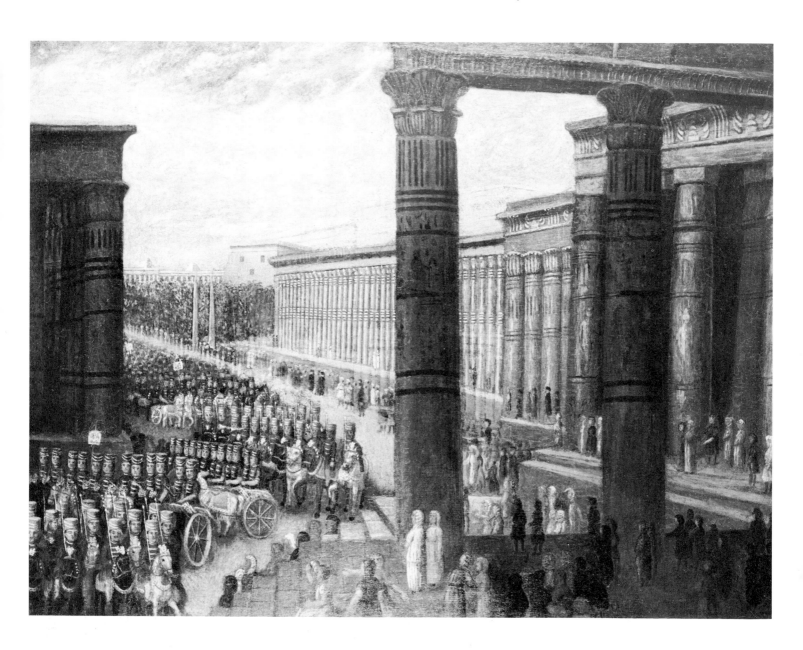

The singular story of Jephthah's rash vow, with its startling similarity to elements of Greek tragedy, was of particular appeal during the Romantic era and was, in fact, the subject of dramatic renderings in female academies of the period. This skillful execution of the most poignant moment in the story shares more in common with these literary versions than with the biblical narrative itself. The life of the young girl, spent in music and idle female chatter, is accidently pledged to God by her father. Standing near the black and white tiles, the Greek pillar, and the Gothic cathedral (probably copied from an English landscape print), Jephthah's daughter is here a reminder of the contemporary Romantic attention paid to the languishing beauty in death.

Jephthah's Return, Betsy B. Lathrop, possibly American, watercolor on silk, 1812, 22 x 25¾ inches, Abby Aldrich Rockefeller Folk Art Center, Williamsburg, Virginia.

In another version of the story of Jephthah's daughter, the Gothic castle is replaced by a simple church, perhaps familiar to the young lady who painted the picture. Framing the church are cross-trunked trees, a motif popular in Philadelphia mourning pictures dedicated to George Washington. Here, Jephthah's daughter is depicted as a very young child. Her exceptional youth, of course, adds additional sentimental poignancy to the scene, but reveals a naive misreading of the actual biblical story in which, before she is sacrificed, she bewails her virginity.

Old Testament Picture, possibly *Jephthah's Rash Vow,* artist unknown, probably American, watercolor on paper, c. 1820-40, 16 x 21 inches, Old Sturbridge Village.

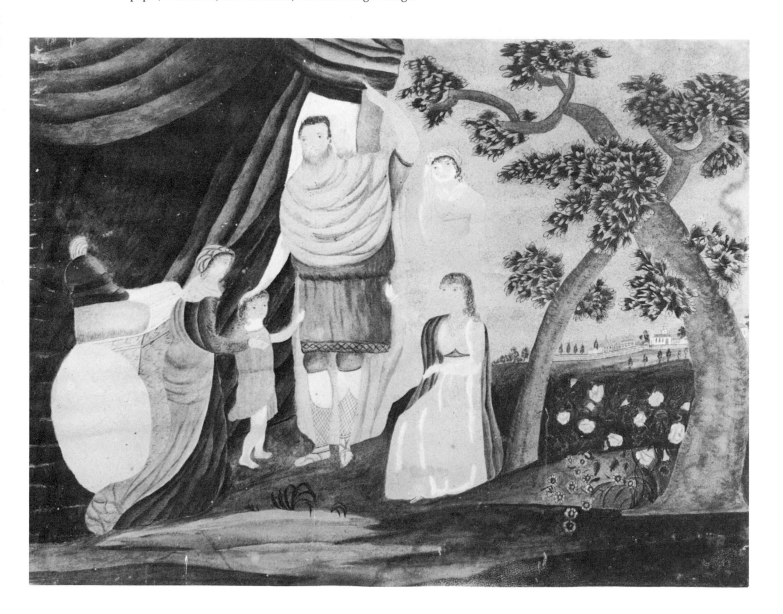

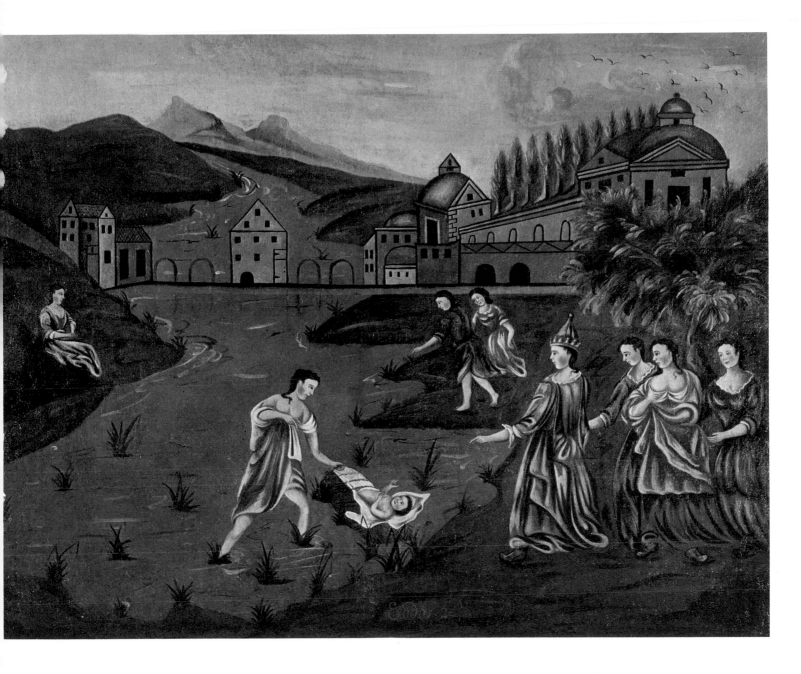

The Finding of Moses, artist unknown, American, c. 1700-1725, oil on canvas, 27 x 35 inches, Abby Aldrich Rockefeller Folk Art Center, Williamsburg, Virginia.

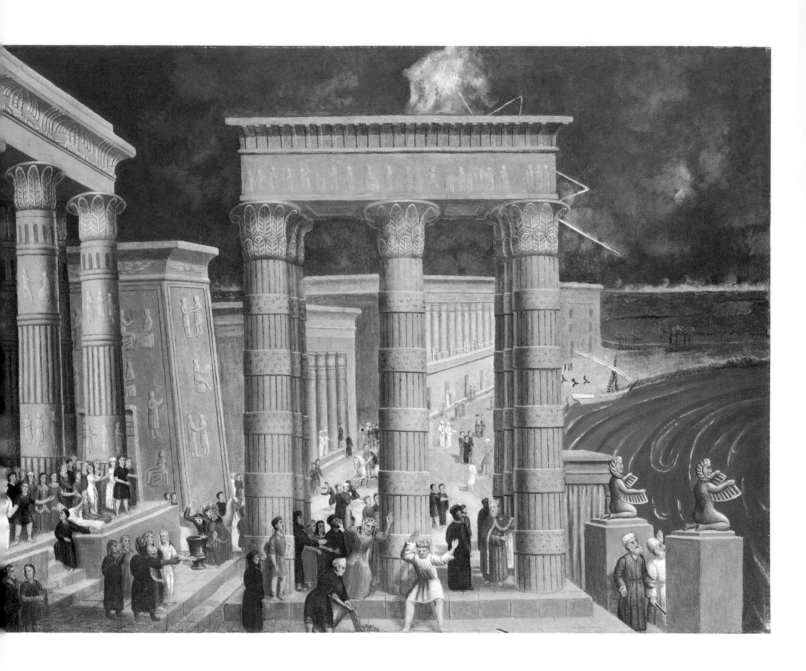

He Turned Their Waters into Blood, Erastus Salisbury Field, American, c. 1865-1880, oil on canvas, 30¼ x 40½ inches, National Gallery of Art, Gift of Edgar William and Bernice Chrysler Garbisch.

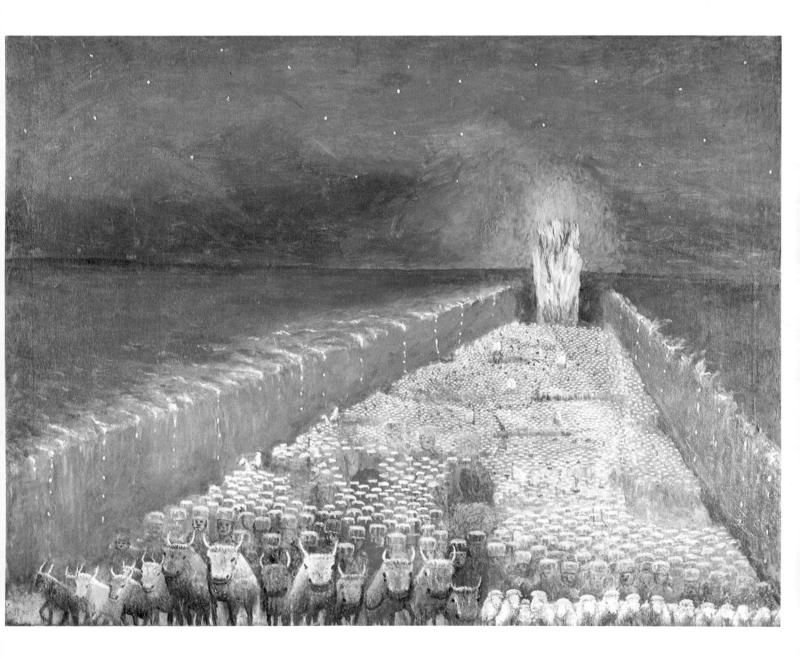

Israelites Crossing the Red Sea, Erastus Salisbury Field, American, c. 1865-1880, oil on canvas, 34½ x 46 inches, Collection of Mr. and Mrs. W. B. Carnochan, Atherton, California.

The Ark of the Covenant, Erastus Salisbury Field, American, c. 1845, oil on canvas, 20 x 24⅛ inches, National Gallery of Art, Gift of Edgar William and Bernice Chrysler Garbisch.

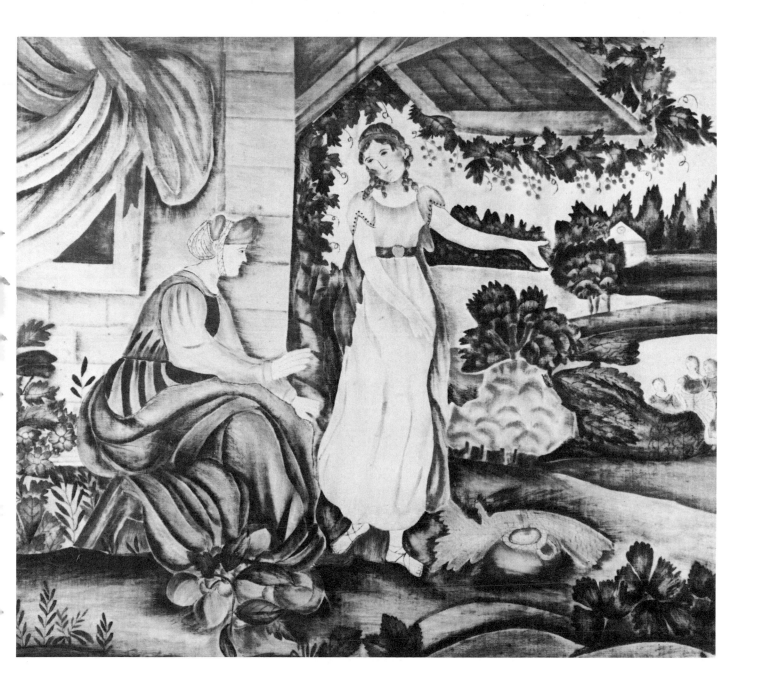

"And Ruth the Moabitess said unto Naomi, Let me go now to the field, and glean ears of corn after him in whose sight I shall find grace. And she said unto her, Go, my daughter" (Ruth 2:2). This literal rendering of the biblical scene is not without its iconographic elements. Naomi, the Hebrew, wears a hat, often symbolic not only of age but of the Old Law. Ruth, whose mixed-marriage with Boaz will lead to Jesse, the root of the tree of David and of Jesus, stands under a grape arbor, representative of the New Law.

Ruth and Naomi, artist unknown, probably American, painting on velvet, 1825-1850, 22 x 27 inches, Old Sturbridge Village.

One of the most idyllic moments in the Old Testament is literally portrayed in this 19th-century work: "Then said Boaz unto Ruth, . . . Go not to glean in another field, neither go from hence, but abide here fast by my maidens . . . The she fell on her face, and bowed herself to the ground, and said unto him, Why have I found grace in thine eyes, that thou shouldest take knowledge of me, seeing I am a stranger?" (Ruth 2:9-10). Ruth, in a splendid Empire gown and a neo-Grecian hair-do, supplicates herself before a properly attired Old-Testament Boaz.

Ruth and Boaz, artist unknown, probably American, oil on velvet, early 19th century, 19⅛ x 25⅛ inches, New York State Historical Association, Cooperstown.

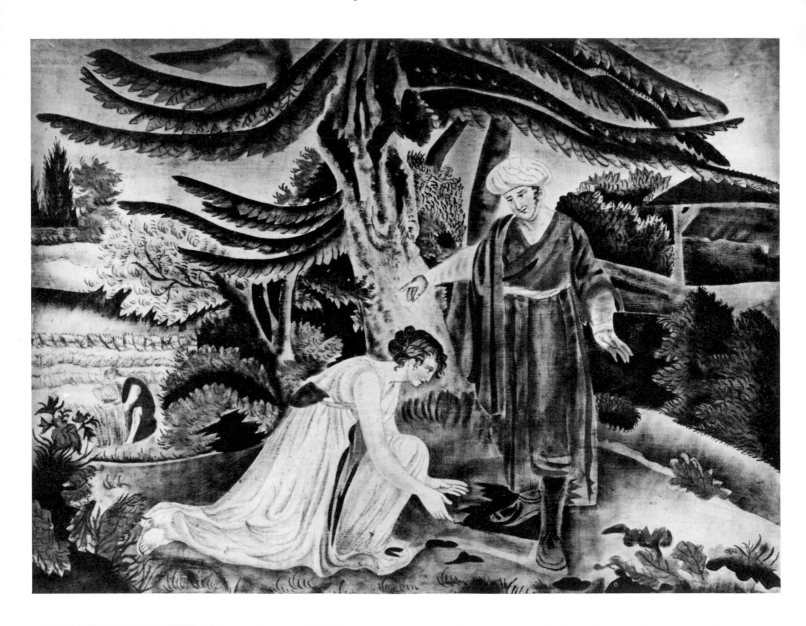

The immortal tale of David and Goliath, simple in story and in style, is well-suited to the almost whimsical engraving of Jonathan Fisher. Short, ruddy, and the youngest of eight sons, David emerges as a hero by defeating the ten-feet-tall Goliath, described in I Samuel as having "a helmet of brass upon his head," "a coat of mail," and "the staff of spear like a weaver's beam." Armed with only the courage given him by God — his "spiritual armor" — David "prevailed over the Philistine with a sling and a stone."

Behold the Tall Goliath Fall, engraving in *The Youth's Primer* by Jonathan Fisher (Boston, 1817), Sinclair Hamilton Collection, Princeton University Library.

ABSALOM slein by JOAB.

And Absalom rode upon a mule, and the mule went under the bows of a great Oak and his head caught hold of the oak and he was ta... up between the heaven and the earth and the mule that was under him went away. II Sam...

Opposite: Biblical art drew as much from tradition as from the Bible itself. As troops mass in the background, Absalom, who dared to rebel against his father, King David, hangs by his long hair from an oak tree before Joab and his men kill the traitor. Although tradition holds that Absalom's *hair* was caught in the tree, the biblical story implies that he caught his *neck* between branches while riding his mule. This bizarre tradition prevails even today and seems to have caught the popular imagination in much the same manner as the story of Samson's locks.

Absalom Slein by Joab, attributed to Caroline Joy, probably Massachusetts, watercolor on paper, c. 1830-1835, 7¾ x 5¾ inches, Abby Alrich Rockefeller Folk Art Center, Williamsburg, Virginia.

The character of King Solomon is ambiguous in the Bible — his enormous wealth and love of luxury is praised as a sign of God's favor, but his harem of foreign wives is sometimes damned as apostacy — and both elements are present in the story of the Queen of Sheba's procession to the court of Solomon. The Hebrew monarch's luxury, symbolized pictorially by the topiary trees, is clouded by the presence of monkeys by this throne, suggesting both his pagan marriages and man's base similarity to the lower creatures. Jesus comments on "Solomon and all his glory" as less worthy of admiration than the common lilies of the field (Luke 12:27). But Solomon's court remained a heady subject for artists of every period nonetheless.

Solomon and Sheba, Ivares Daniel Andersson, Swedish, paint on paper, c. 1799-1870, 41⁵⁄₁₆ x 74¹³⁄₁₆, Nordiska museet.

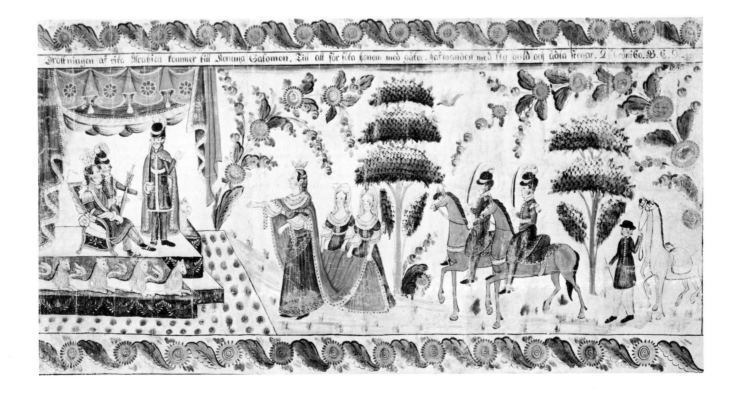

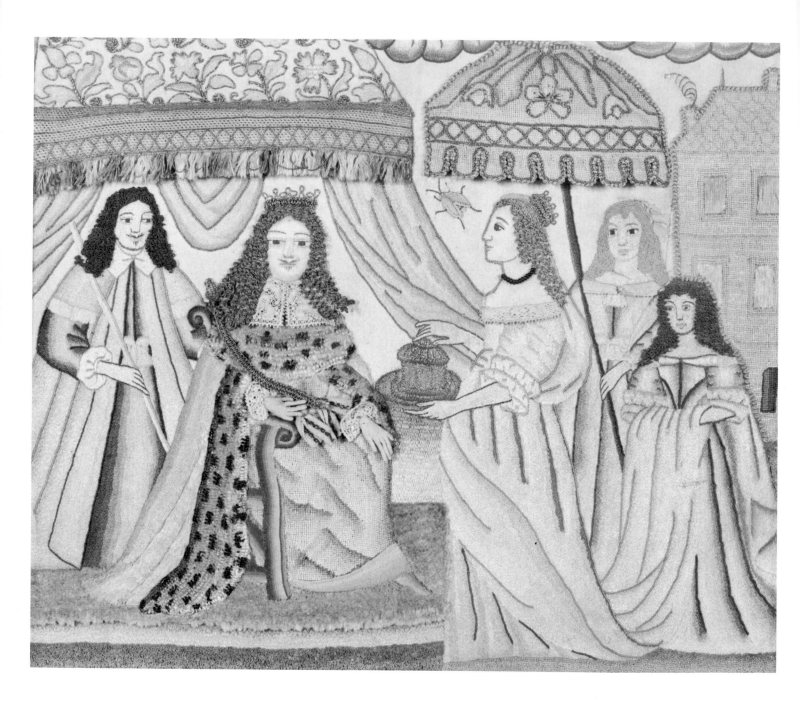

Dressed in 17th-century finery, and with a 17th-century structure in the background, Solomon receives his royal visitor to his court. Each is beneath an individual royal covering. The tent over Solomon's head has long signified a tabernacle or holy place, a symbol that in 1535 churchman Thomas Wilcox described as "spiritual furniture." The Queen's umbrella is reminiscent of the one used to shield Pharaoh's daughter (see p. 61). The iconographic beetle may possibly suggest profane love, Solomon's greatest failure, since tradition insists that the Hebrew took the Arabian queen as his concubine.

The Queen of Sheba Bearing Gifts, artist unknown, English, silk, chenille and metallic threads, ermine, lace, and hair on satin, 17th century, 8¾ x 10½ inches, The Shelburne Museum.

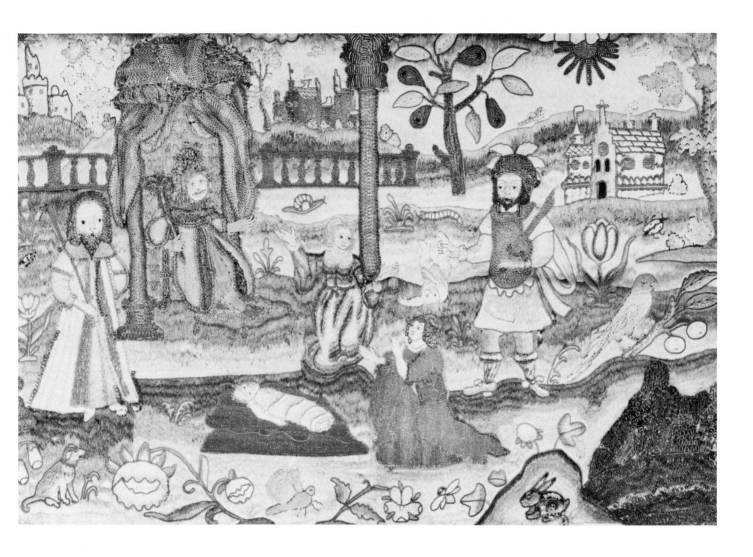

Sometimes a representation of Jesus himself, Solomon is the great symbol of Old Testament wisdom, traditionally illustrated by his decision in the case of the two women who claimed the same baby (I Kings 3:16-28). Within a garden of iconographic opposites — the "good" palm and the "evil" pear tree, the faithful dog and the lecherous rabbit, the butterfly of hope and the crawling insects of the flesh — Solomon proposes to settle the argument by cutting the baby in two with a sword, giving half to one woman and half to the other. (The baby is drawn twice, illustrating the movement in time of the story.) Symbols of sexual sin predominate (notice the bird on the fruited disembodied branch; see p. 38), because the two women are described in the original story as "harlots." Notice, too, the suggestion of an enclosed garden — the landscape of the soul.

The Judgment of Solomon, artist unknown, English, metallic and silk floss on satin, c. 1600-1690, 9½ x 14 inches. The Shelburne Museum.

Jeroboam I became the first king of the Northern kingdom of Israel after the rebellious division of Hebrew territory in the reign of Rehoboam, the last king of the United Monarchy of David and Solomon and the first ruler of the Southern kingdom of Judah. The sin of King Jeroboam I, his divisive rebellion against the house of David and the division of the land of Moses, is symbolized by the two trumpeting messengers. The coronation scene, unmentioned in the Bible, is completely imaginary.

The Crowning of King Jeroboam, artist unknown, possibly New York, oil on canvas, 18th century, 27 x 37½ inches, Albany Institute of History and Art.

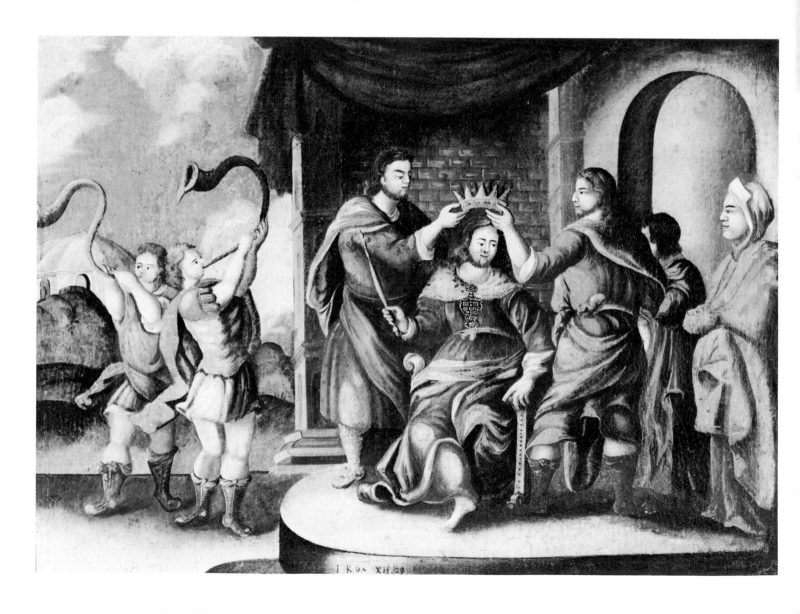

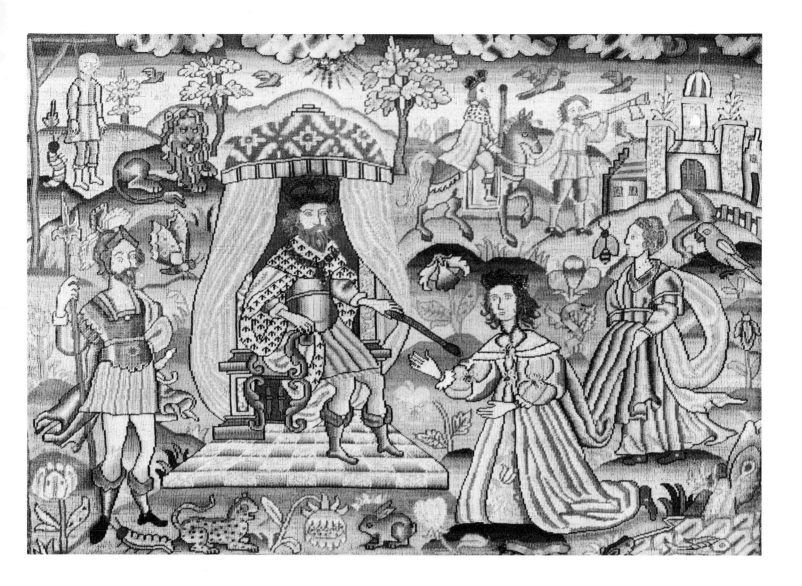

The entire story of Esther and Ahasuerus unfolds in a needlework scene crowded with traditional iconographic symbols. That the king's attraction to the Jewish heroine is largely sexual (she replaced Vashti as queen only because of her beauty) may be seen by the rabbit and leopard between the two central figures. The butterfly of hope hovers between the king and the hanging figure of the villainous Hamen (*top left*). Mordecai, arrayed in royal attire, is brought to the Persian palace (*top right*). Above all is the presence of God (never once mentioned in the Book of Esther itself) in the sun within a cloud.

Esther and Ahasuerus, artist unknown, English, needlework on linen, second half of the 17th century, 12 x 7 inches, The St. Louis Art Museum, Collection of Mrs. William A. McDonnell.

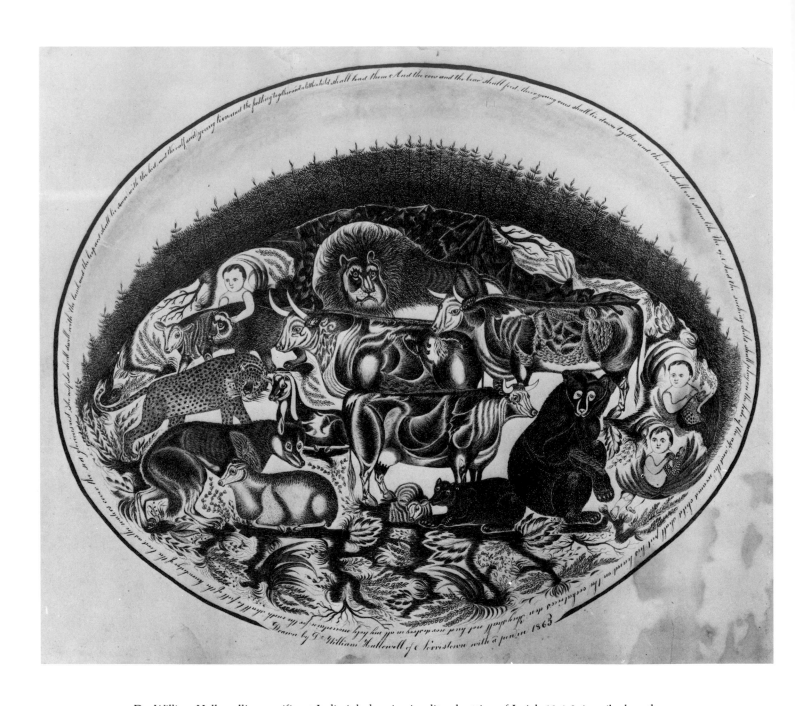

Dr. William Hallowell's magnificent India-ink drawing is a literal setting of Isaiah 11:6-9, inscribed on the outer rim of the oval: "The wolf also shall dwell with the lamb, and the leopard shall lie down with the kid; and the calf and the young lion and the fatling together; and a little child shall lead them," etc. To complete his oval, the artist borrows two words from verse 10 that sum up the Messianic teaching of Isaiah: "glorious rest." Notice that the child, mentioned three times in Scripture, is rendered three times. (See Edward Hicks's Quaker setting of the same passage on p. 89.)

A Peaceable Kingdom, Dr. William Hallowell, American, drawing on paper with India ink, 1865, 15¾ x 19¾ inches, New York State Historical Association, Cooperstown.

In an operatic manner worthy of Hollywood many decades later, the artist concentrates on the bacchanalian licentiousness of Belshazzar's feast and upon God's presence in holy lightning — both absent in the story itself. Ignored is the disembodied hand that wrote the message "mene, mene, tekel, upharsin," causing Belshazzar's knees to "smite one against another."

Belshazzar's Feast, engraved by A. B. Walter, published by J. C. McCurdy & Co., 18 x 26⅛ inches, Abby Aldrich Rockefeller Folk Art Center, Williamsburg, Virginia.

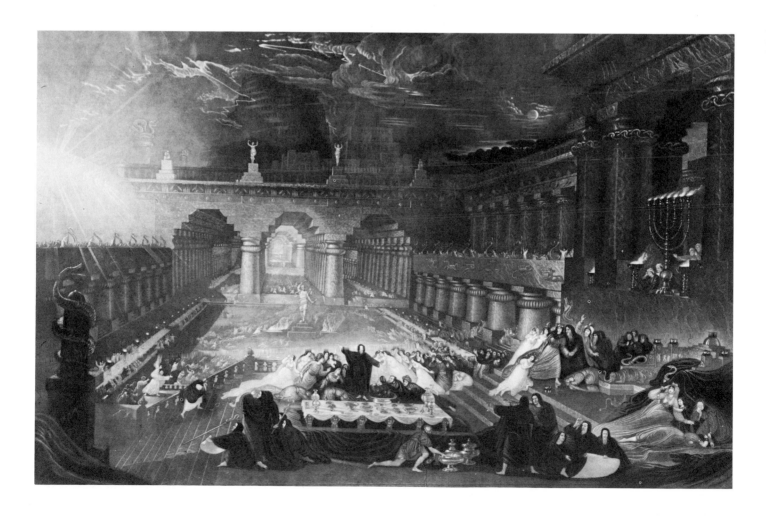

Taking off her widow's mourning sackcloth, Judith of Bethulia dresses in robes, bracelets, and a maiden's headdress to seduce and behead Holofernes, the commander-in-chief of the enemy army. This 17th-century needlework picture captures Judith's great moment of triumph: "Behold the head of Holofernes . . . ; the Lord hath smitten him by the hand of a woman." On the right arm of Judith's maid is a saddle-type bag that had held the bloody head — another detail true to Scripture.

Judith Holding the Head of Holofernes, artist unknown, English or American, silk and wool on linen, late 17th century, 11 x 9½ inches, Private Collection.

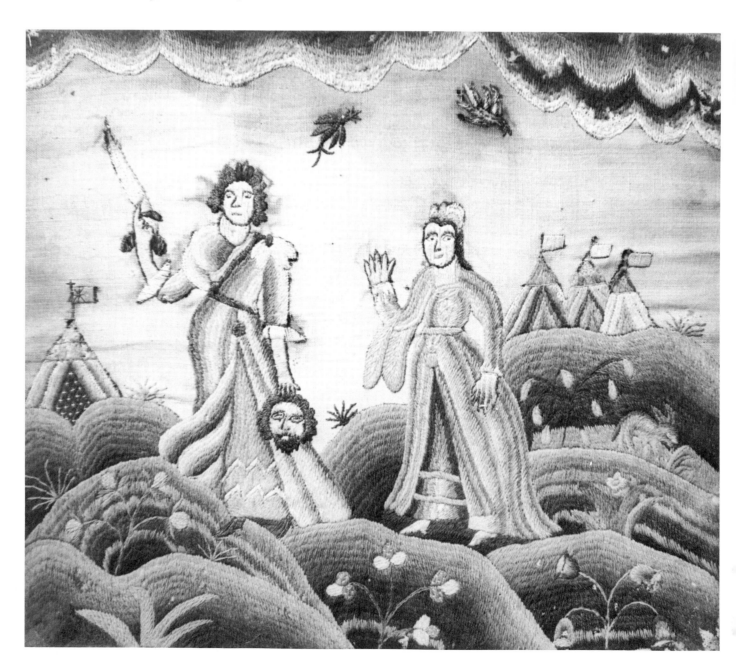

Disguised in the Book of Tobit as Azarias, the companion of Tobias, Raphael ("God heals") is the angel "who is set over all the diseases and all the wounds of the children of man" (Enoch 40:9). "He was sent to heal" Tobit of his blindness by means of the inner organs of the fish that Tobias caught in the Tigris (Tobit 3:16f.). The scene is a literal translation of the Apocryphal story — including Tobias's faithful dog.

The Homecoming of Tobias with the Angel Raphael, artist unknown, probably Dutch, wool and silk on wool, c. 1700, 18¾ x 21¾ inches, The St. Louis Art Museum.

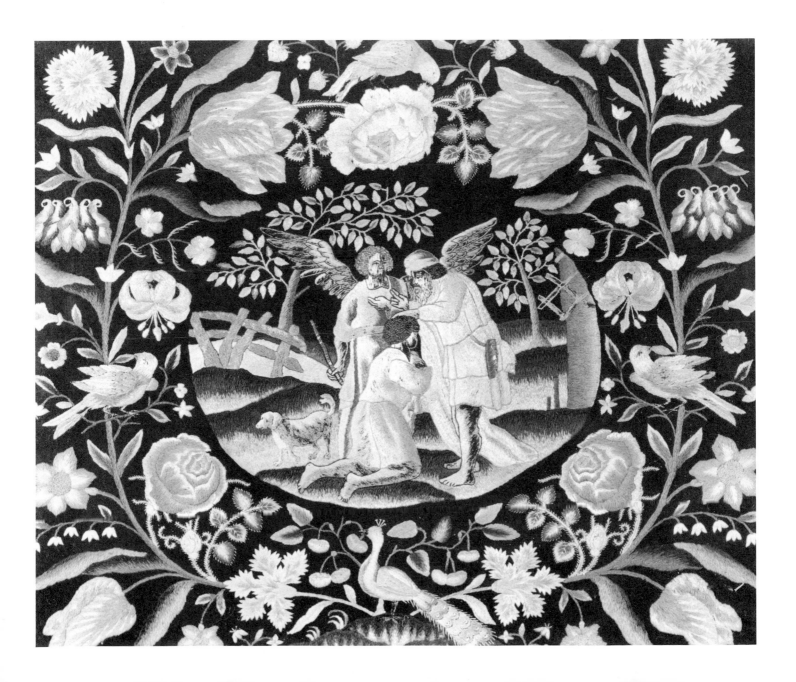

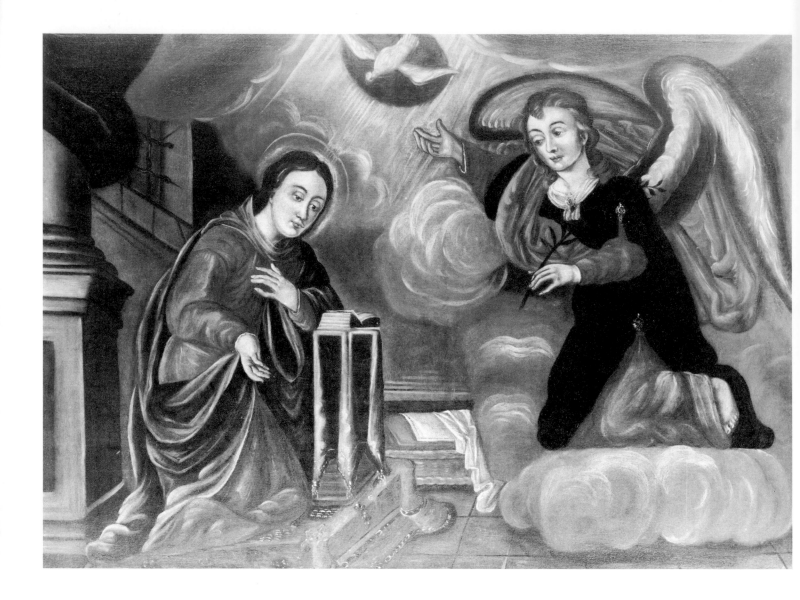

The angel Gabriel announces to Mary that she will be the mother of the Messiah, "the son of God."
Around the platform on which she kneels in prayer is a linked chain — the chain of eternity — an
iconographic reference to those who are entrusted with the Gospel. Although the story of the Annunciation
is most poetically related in the Gospel of St. Luke, the dove — representing the Holy Spirit — is a symbol
borrowed from the Gospel of St. John.

The Annunciation, artist unknown, possibly Albany, New York, oil on wood panel, c. 1710, 23 x 33
inches, The Philadelphia Museum of Art, gift of Edgar William and Bernice Chrysler Garbisch.

The meeting of Mary and Elizabeth is a poignant moment, filled both with human wonder at the miraculous births that await the women and at the predestining purpose of God. At Mary's greeting, the unborn herald — John the Baptist — leaps for joy to greet his unborn Lord. Elizabeth and Mary have always been associated in sacred art, so their presence in this superb Swedish folk painting is hardly surprising.

Mary Greeting Elizabeth, Kers Erik Jonsson, Swedish, paint on paper, 26⅜ x 22 inches, Nordiska museet.

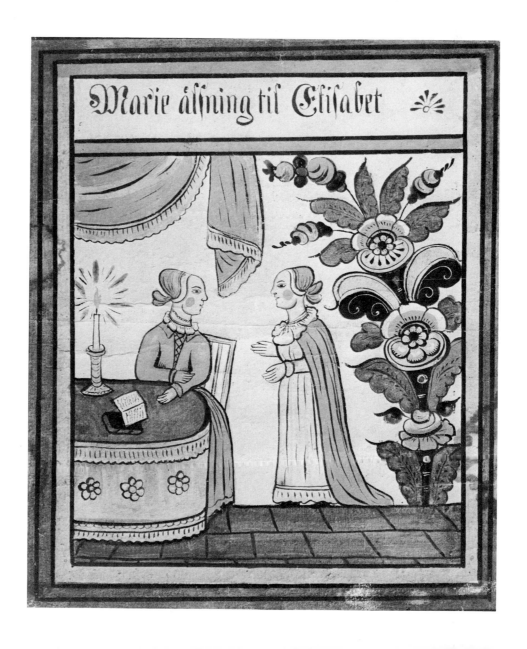

This Nativity scene — elegant, tranquil, and moving — derives its appeal not from such contrasts as innocence and sin, but by artistic concentration upon a single point: pure love. The spotlessness of both Mother and Child, so admired by the cherubim and the "heavenly host" (the stars), suggests the figurative image used by a midwife in the English mystery plays who observed that Jesus left Mary's body "as the sun passes through glass."

Mary and Jesus, artist unknown, probably Pennsylvania, Fraktur hand drawn, lettered and colored on wove paper, c. 1830, 9 x 7 inches, The Free Library of Philadelphia and The Pennsylvania German Society.

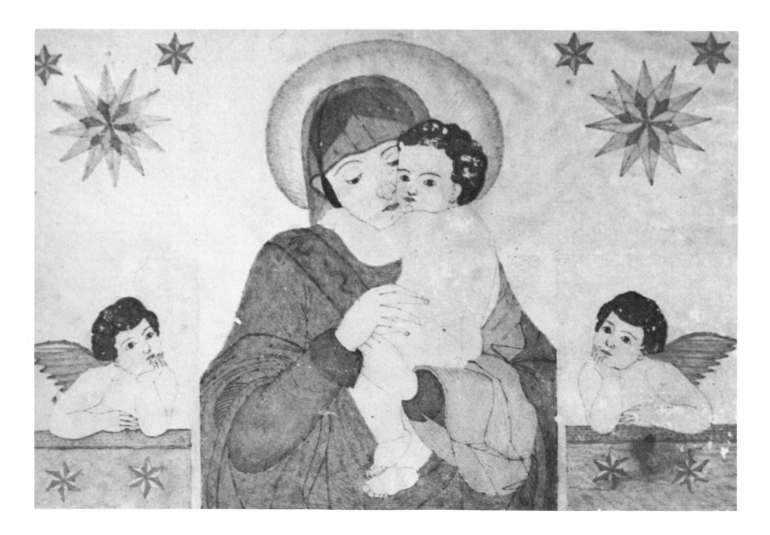

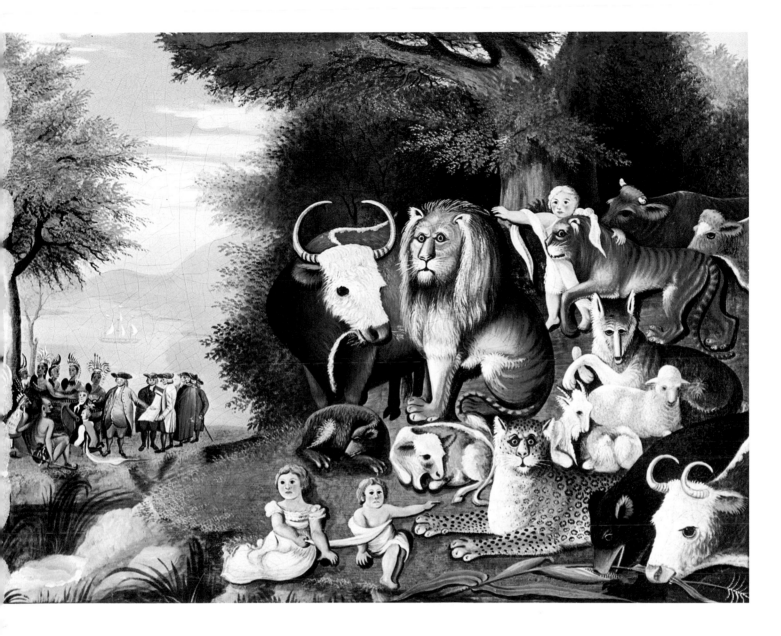

The Peaceable Kingdom, Edward Hicks, American, c. 1830-1840, oil on canvas, 17½ x 23½ inches, Abby Aldrich Rockefeller Folk Art Center, Williamsburg, Virginia.

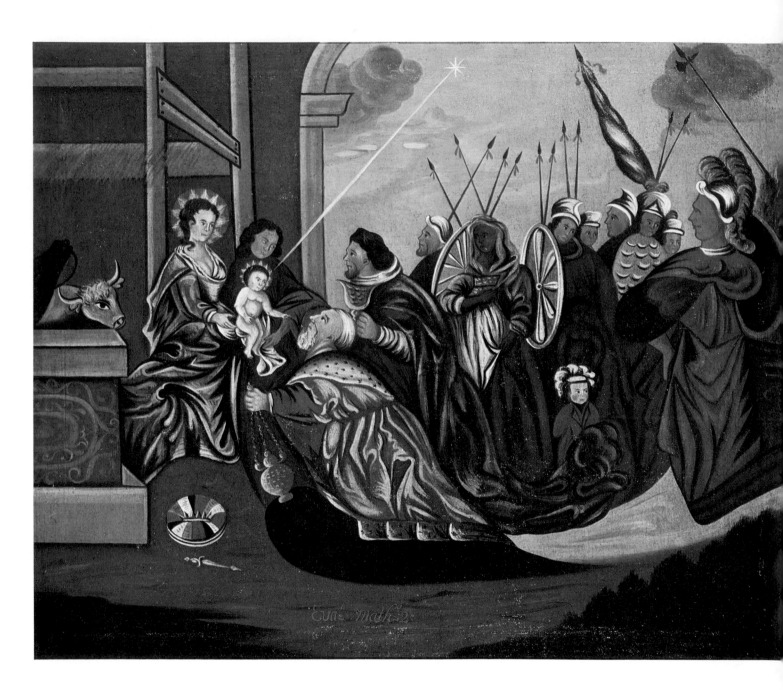

Adoration of the Magi, artist unknown, American, c. 1700-1725, oil on canvas, 29½ x 36⅝ inches, Abby Aldrich Rockefeller Folk Art Center, Williamsburg, Virginia.

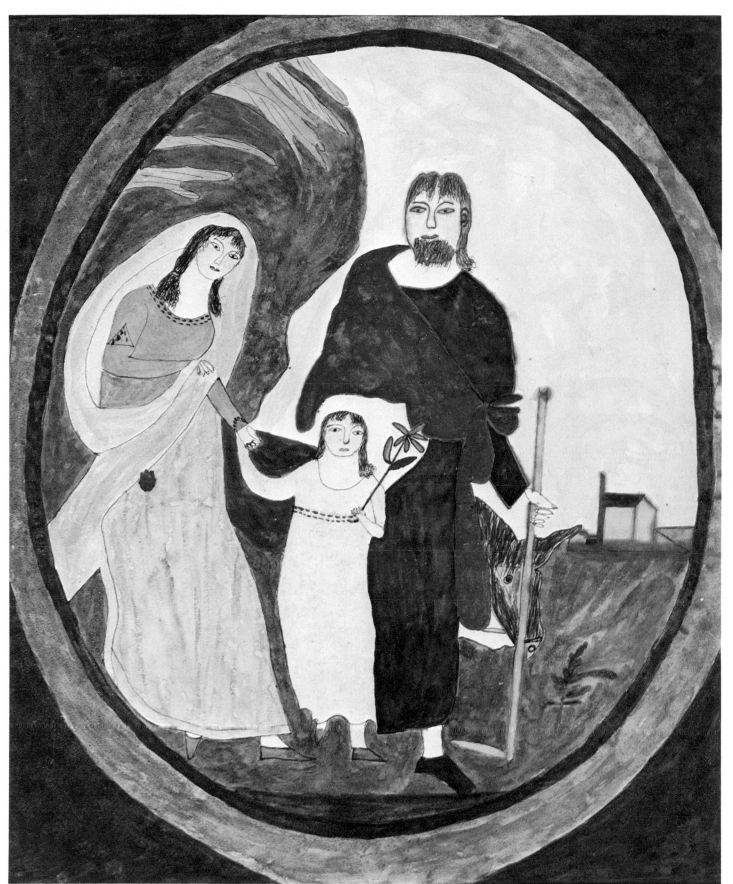

The Good Samaritan, artist unknown, possibly New England, c. 1800-1825, oil on wood, 19⅛ x 36⅝ inches, Abby Aldrich Rockefeller Folk Art Center, Williamsburg, Virginia.

The first worshippers of Jesus — the shepherds — despised by religious hypocrites because their occupation made them neglectful of religious observance, are the forerunners of the multitude of humble folk who are to throng him in his public ministry. The adoring angels represent the joy in heaven at the prospect of Jesus's mission — the Good Shepherd's rescue of the lost sheep.

Adoration of the Christ Child, artist unknown, Pennsylvania, silk, chenille, and watercolor on silk, early 19th century, 20 x 26½ inches, The St. Louis Art Museum, Collection of Mrs. William A. McDonnell.

Opposite: A radiantly happy Mary presents her son to the three wise men, each bearing gifts, and each garbed in contemporary 19th-century dress. Above them shines the star — in legend, actually an angel — that guided them from the East. The key word of St. Matthew's nativity story — "joy" — is here almost contagiously communicated.

The Three Wise Men, artist unknown, probably Swedish, paint on linen, early 19th century, 18 x 22 inches, Collection of Mr. and Mrs. Walter L. Wolf.

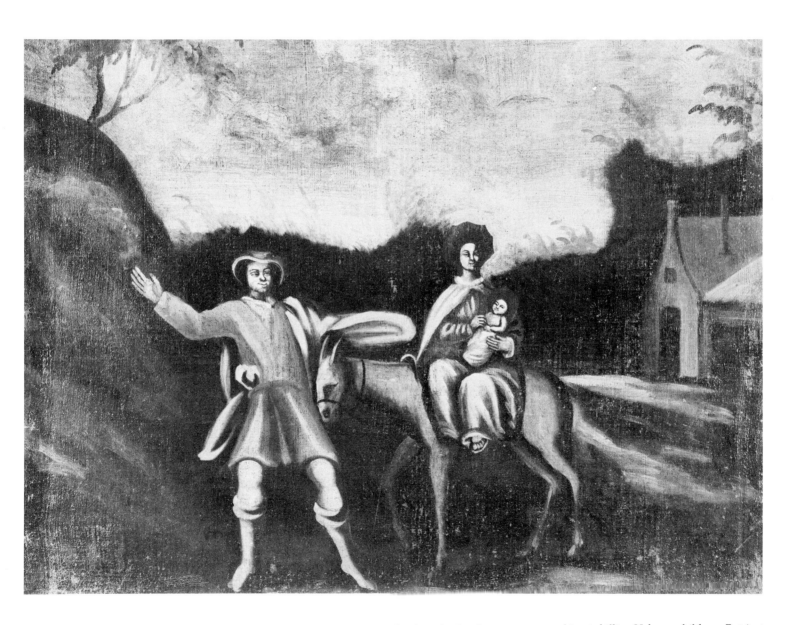

The flight into Egypt is a repetition of the events which happened before the Exodus: once more a king is killing Hebrew children. But just as Moses had been hidden and saved, so now Jesus is to be saved by flight; and God's purpose will be fulfilled, because He will call His son out of Egypt.

The Flight into Egypt, artist unknown, possibly Albany, New York, oil on canvas, 18th century, 23½ x 29 inches, Albany Institute of History and Art.

This is a literal translation of St. Matthew's description of Jesus's baptism, down to the very description of John the Baptist's "garment of camel's hair and a leather girdle around his waist." The cross is an artistic invention prefiguring the Crucifixion. But such license has its place in a scene in which the "heavens were opened . . . and the Spirit of God descended like a dove." Since the ancient rabbis likened God at the *first* creation to a dove, Matthew's description suggests a *new* creation, the dove and the water reinforcing the Christian notion of Jesus as the new man, the last Adam, and "the beginning of God's creation." This new creation is visible, therefore, to the observers in modern 19th-century dress on the distant shore.

Baptism of Our Savior, Ann Johnson, possibly New York, watercolor on paper, c. 1840, 19⅞ x 26 inches, Abby Aldrich Rockefeller Folk Art Center, Williamsburg, Virginia.

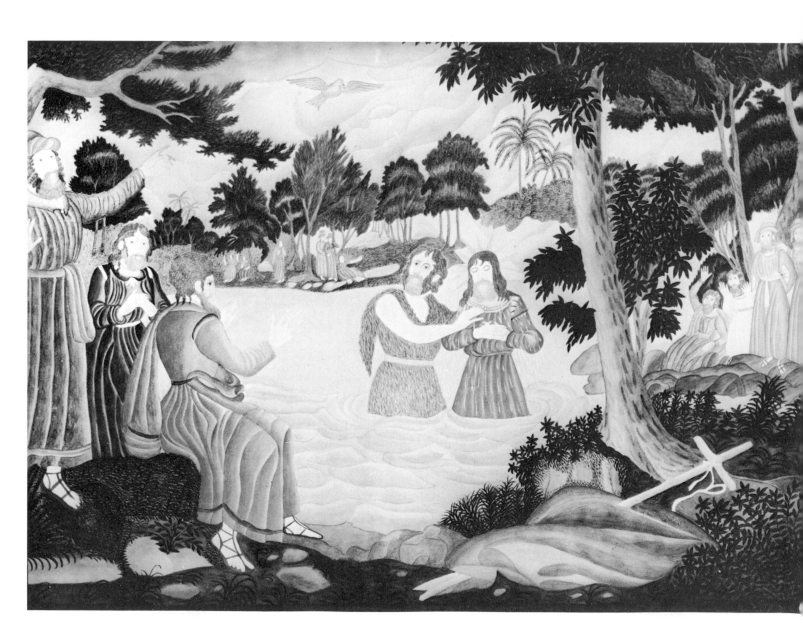

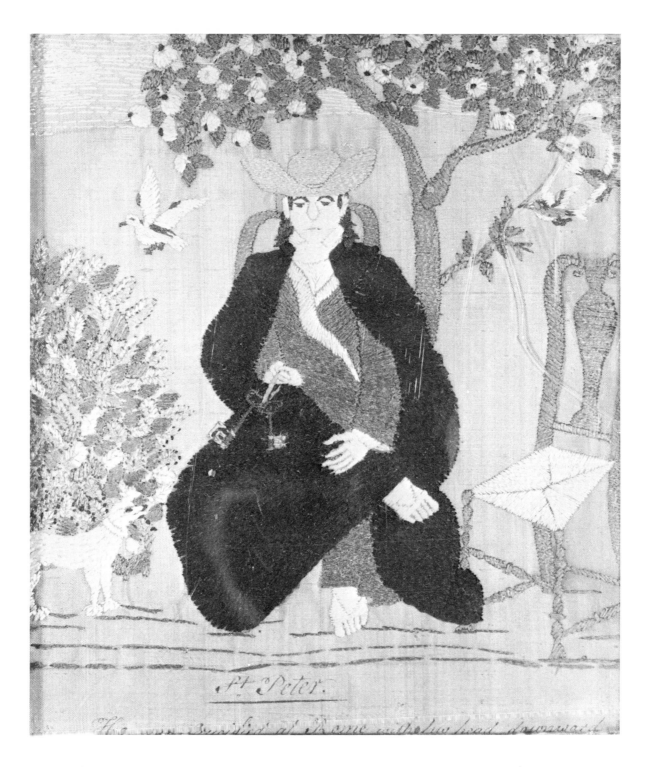

St. Peter.

Above and on the following eleven pages: The Twelve Apostles, Prudence Punderson, Connecticut, crimped floss silks on silk, c. 1775, each 10 x 9 inches, Connecticut Historical Society. [The needlework picture of St. Peter, *above*, is commented upon in the Introduction.]

Andrew, the brother of Peter, was a follower of John the Baptist and the first-called of Jesus's disciples. According to tradition he was crucified at Patrae upon an X-shaped cross — a *crux decussata* — embroidered here behind the apostle. The motif of "St. Andrew's cross" is repeated in the apostle's crossed legs, and his status as patron saint of Scotland is reflected in the thistles on the right.

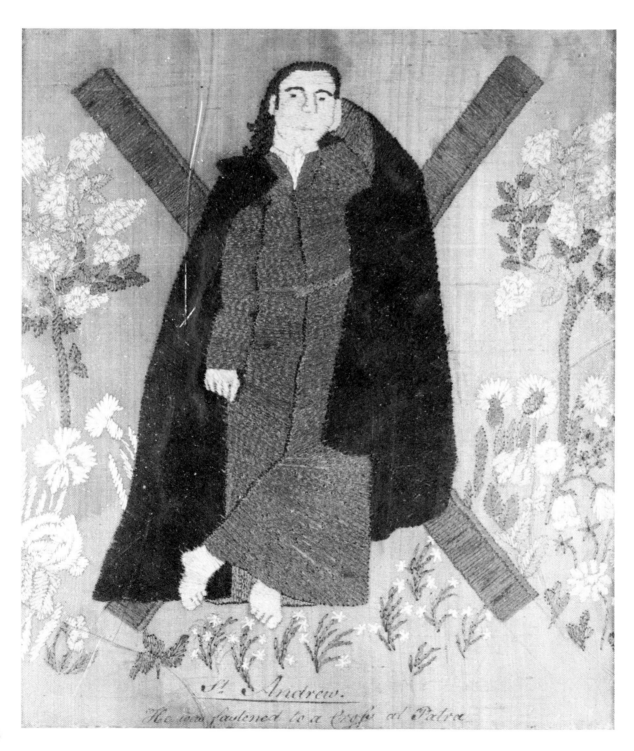

St. Andrew.
He was fastened to a Cross at Patra

According to legend, the body of St. James the Great was placed in a boat in Palestine; the sails were set and it reached the Spanish coast in one day. James is depicted here, therefore, as a pilgrim, as he frequently is in art. The swan, as a symbol of opposites, may suggest the dual disposition of James — passionate but patient — or simply suggest the resurrection of the faithful. The waterlilies are a Christian symbol of charity.

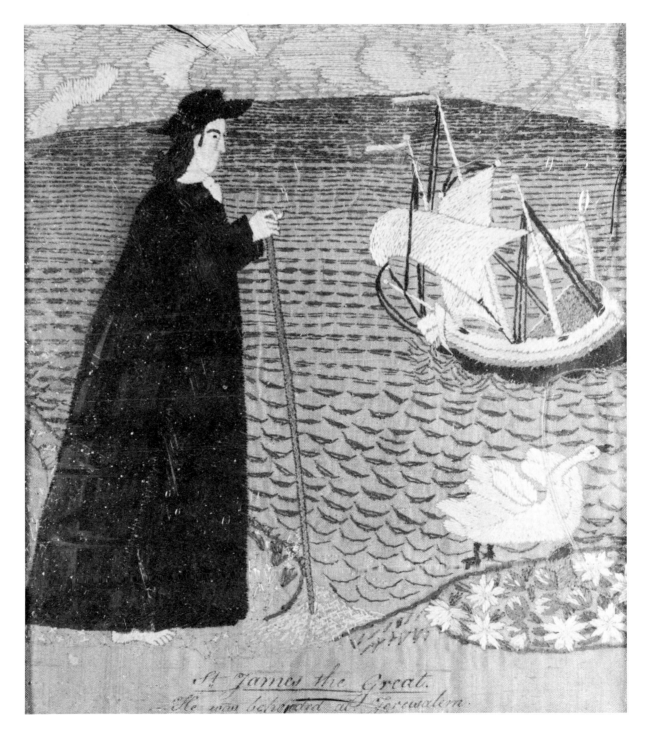

St. James the Great.
He was beheaded at Jerusalem.

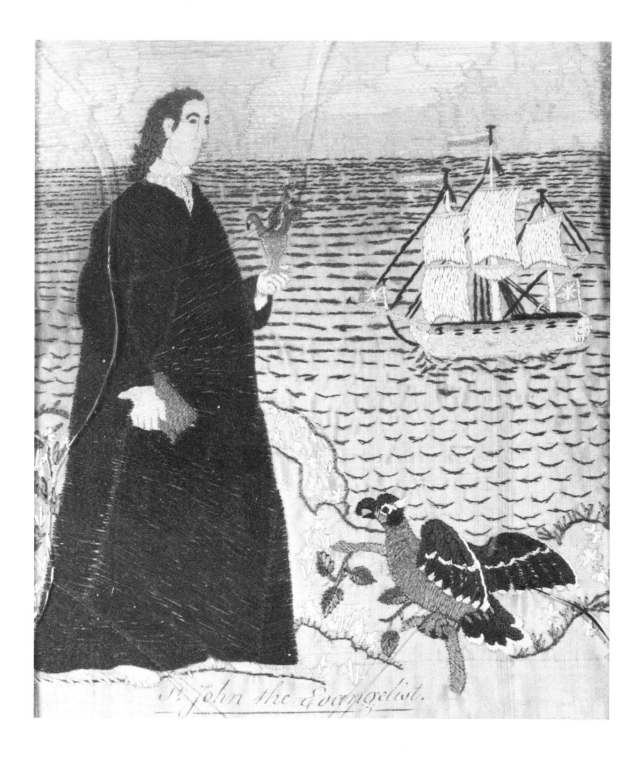

St. John the Evangelist.

Tradition says that St. John wrote the fourth Gospel. His emblem, consequently, is the eagle, inasmuch as he is said to have soared to heaven to gaze on the light of immortal truth with keen and undazzled eyes. John is shown with a cup from which a serpent issues, an allusion to the legend that, as he was about to drink poison and wine, the poison left it in the form of a snake. The ship may suggest the story (John 21:1-7) of the ship on the Sea of Galilee from which John was the first to recognize the risen Christ.

Seated near the flock of the Good Shepherd, the apostle Philip holds the cross on which he was crucified — the very same cross with which he had destroyed a great serpent worshipped by the people of Hieropolis. The vine entwined in the branches is an ancient Christian symbol of Jesus and the apostles and is based on John 15:5 — "I am the vine, ye are the branches."

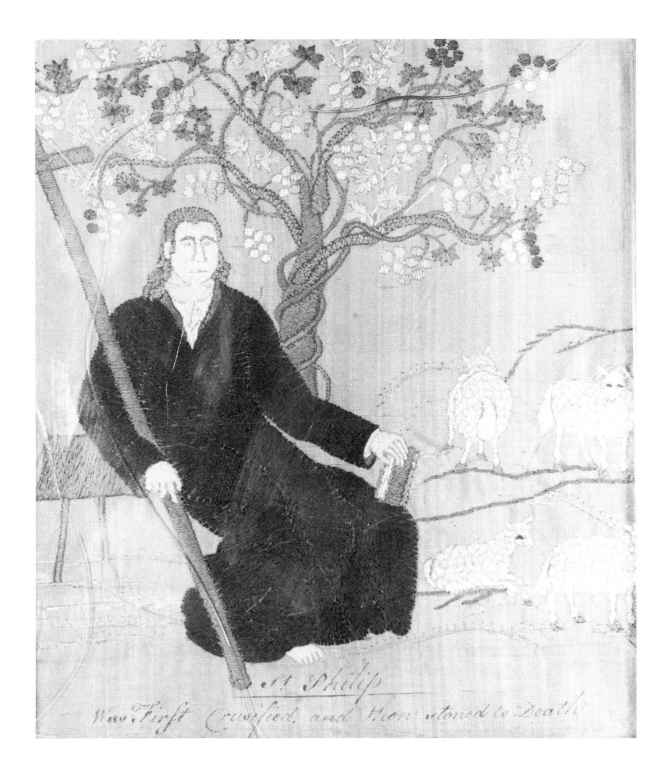

St. Philip
Was First Crucified and then stoned to Death

Bartholomew was believed to have been flayed or skinned alive with the peculiarly-shaped knife pictured here. The conjunction of loaves and fishes and goats in the symbolic landscape suggests the dramatic opposites of Eternal Life and Eternal Damnation. The loaves and fishes (see Matthew 14:17-19) represent the "spiritual food" of faithful Christians; goats symbolize those damned in the Last Judgment. The goats, exotic specimens unfamiliar to Americans, suggest Bartholomew's ministry in the East.

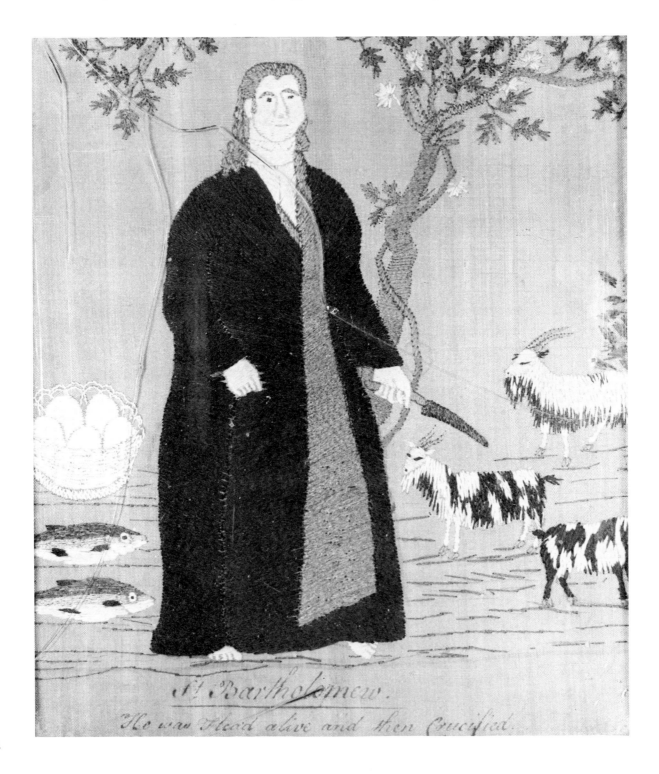

St. Bartholomew.
He was Flead alive and then Crucified.

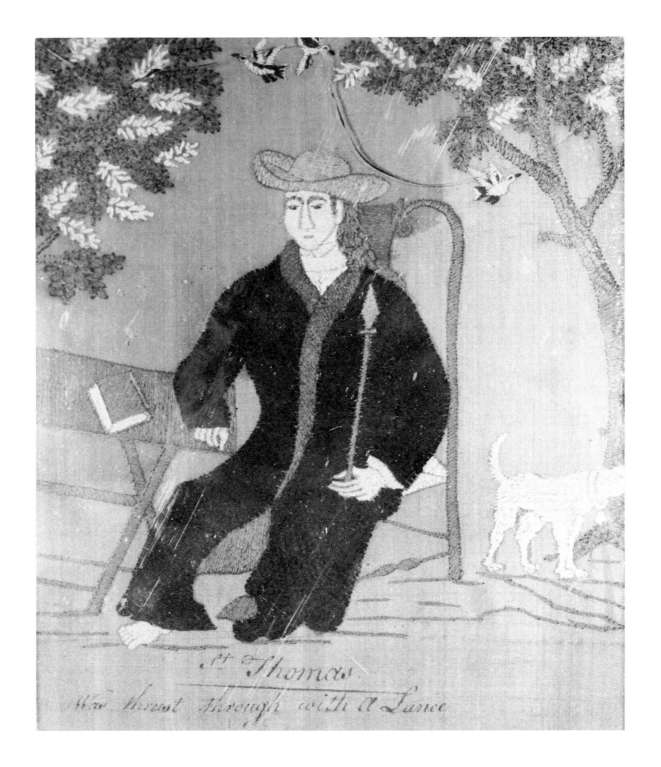

St Thomas
Was thrust through with a Lance

Legend tells us that St. Thomas was the author of the apocryphal *Gospel of Thomas* — hence the book on the table. He holds the lance that was the agent of his martyrdom.

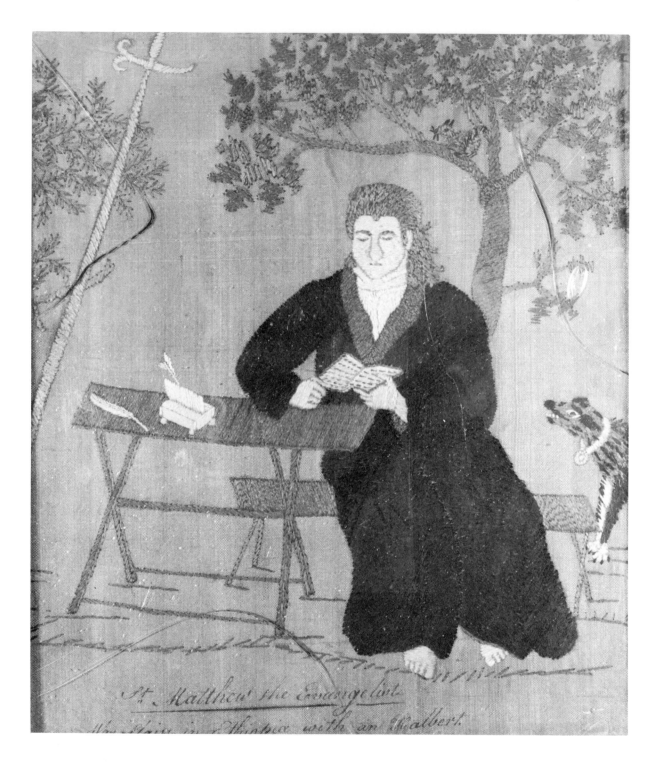

Matthew, a hated publican whose sincere humility caused Jesus to invite him to become a disciple, sits at his table with pen and ink, his Gospel in his hand. Next to him is an axe, the instrument of his martyrdom.

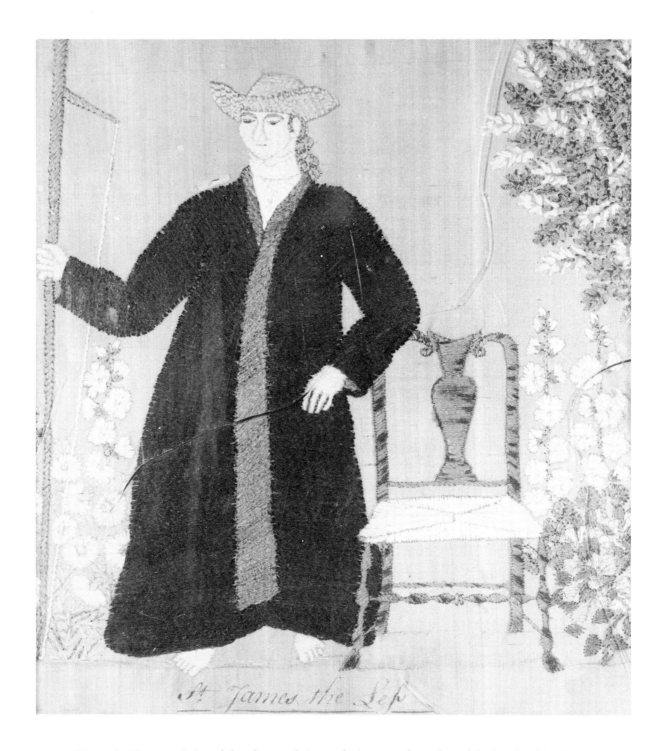

St. James the Less

The early Christians believed that the apostle James the Less was the author of the Epistle of St. James. According to Flavius Josephus, James was stoned to death, but Prudence Punderson follows the more popular story that James was beaten to death with a fuller's bat, the instrument held in the apostle's right hand.

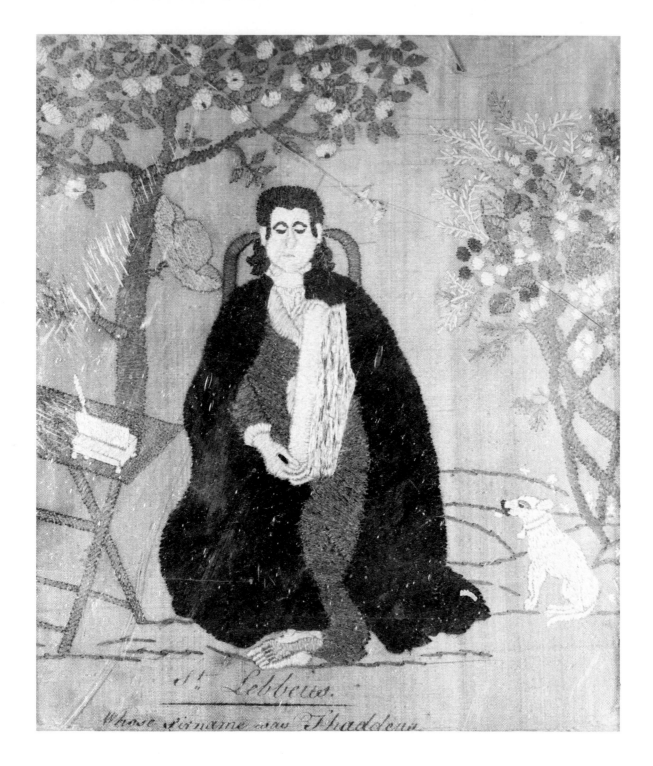

St. Lebbeus.

Whose surname was Thaddeus

Lebbaeus was also called Thaddaeus or Jude and described himself as the brother of James the Less. He is most likely portrayed here with a scroll and with pen and ink because of the traditional, but mistaken, belief that he was the author of the Epistle of Jude.

Simon the Cananaean, known as "the Zealot," was supposed to have preached the Gospel with Jude. According to one legend, he was crucified, and in another even more gruesome story he was sawed apart. In Pendleton's engraving "Noah Building the Ark" (see p. 44), a similar saw is illustrated.

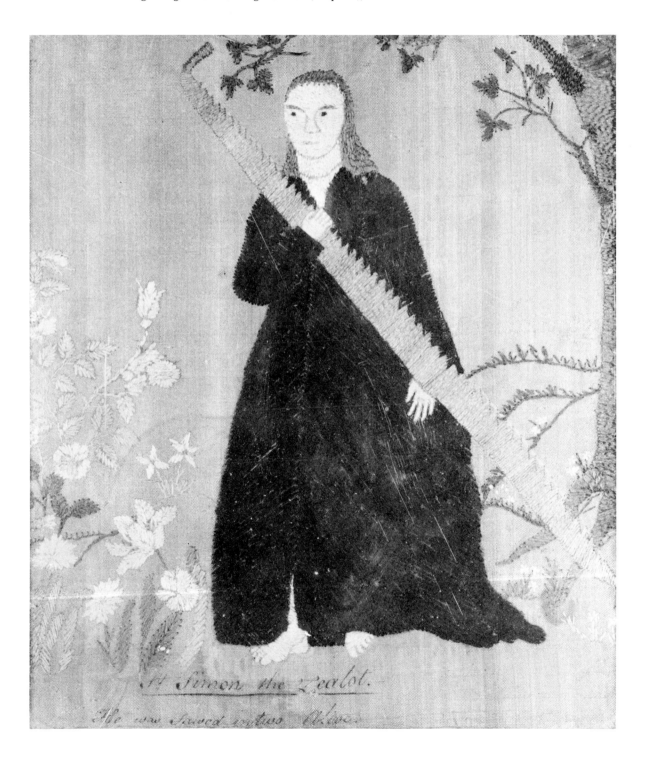

St Simon the Zealot.
He was Sawed into two Oldes.

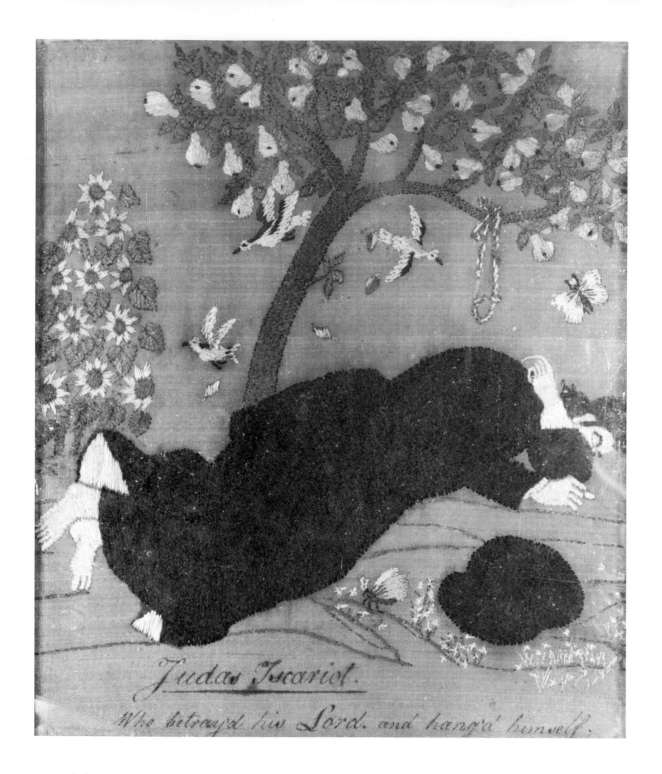

Judas Iscariot.

Who betray'd his Lord. and hang'd himself.

Judas Iscariot lies beneath the symbolically evil pear tree from which he hanged himself. A landscape of traditional symbolic elements stands in opposition to Judas's sinful act. Important elements are a butterfly ascending, suggesting resurrection; and the sunflower, the conventional symbol of Christian obedience because it faces the sun (Jesus) all the day. Significantly, there are *eleven* sunflowers, one for each of the faithful apostles. To reinforce her theme, Prudence Punderson arranges the flowers in triangular form, suggesting the Trinity.

The Parable of the Rich Glutton and the Poor Beggar, Ann Haigh, English, dated 1756, wool on linen, 15½ x 18 inches, The St. Louis Art Museum, Gift of Mrs. William A. McDonnell.

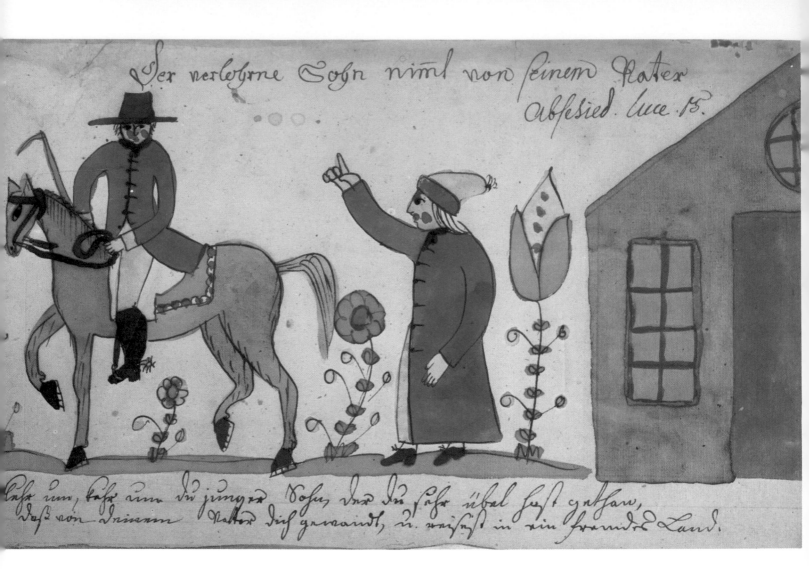

The Prodigal Son Leaves His Father, Friedrich Krebs, Pennsylvania, c. 1800, pen and watercolor, 8½ x 13¼ inches, Pennsylvania Historical and Museum Commission, William Penn Memorial Museum.

The Prodigal Son When He Has No More Money, Friedrich Krebs, Pennsylvania, c. 1800, pen and watercolor, 8½ x 13¼ inches, Pennsylvania Historical and Museum Commission, William Penn Memorial Museum.

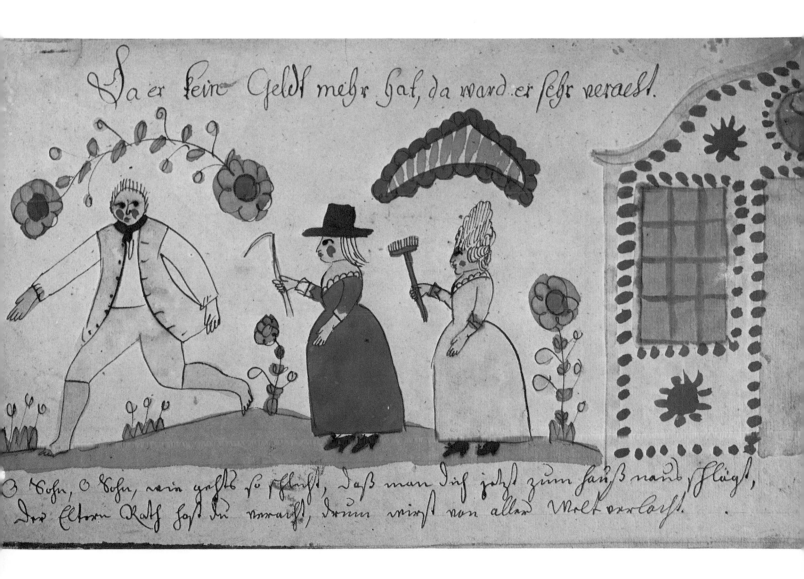

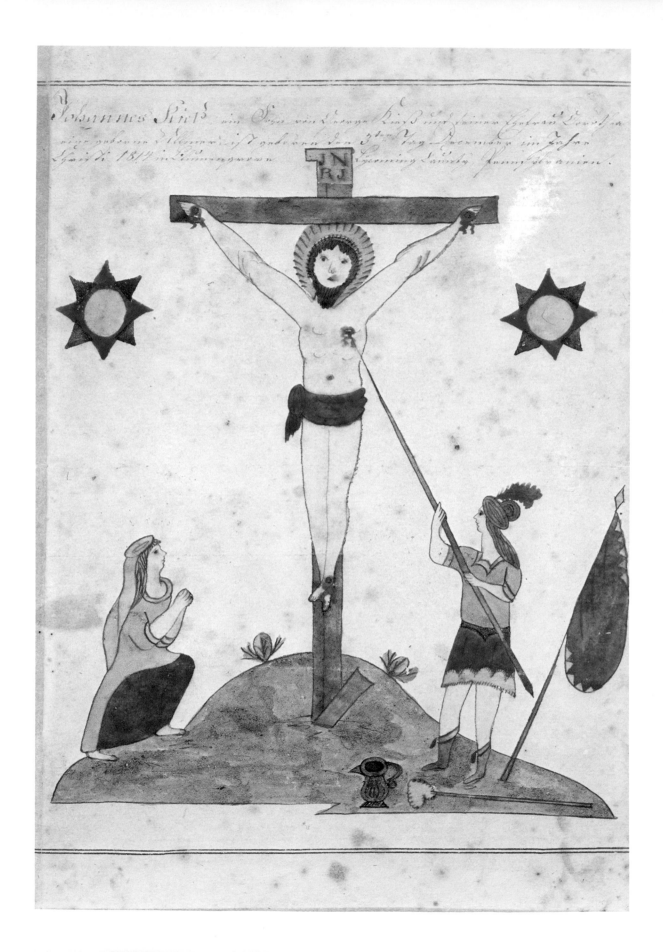

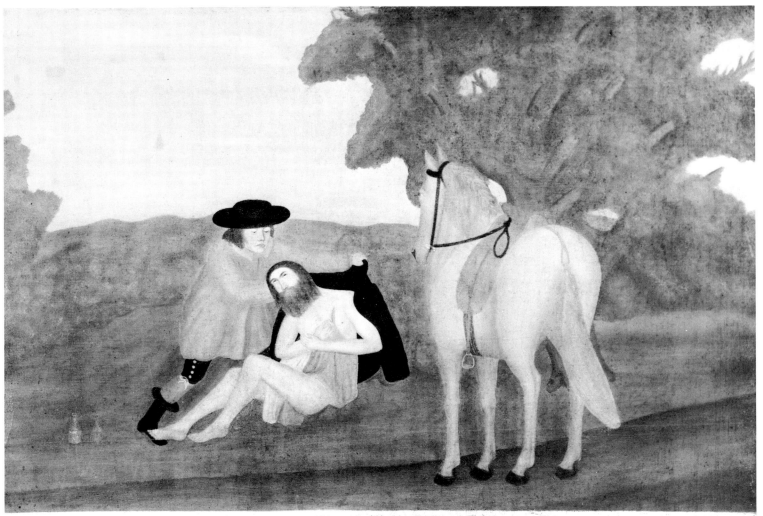

But a certain Samaritan, as he journeyed, came where he was: and when he saw him, he had compassion on him. Luke, 10.33. And went to him, and bound up his wounds, pouring in oil and wine. Luke. 10. 34.

This painting, part of a series illustrating all the episodes in the parable of the Good Samaritan, matches in delicacy and compassion the meaning of the story itself. The very tone of the painting captures the essence of Jesus's point: It is neighborliness, not neighborhood, that makes a neighbor. (Another scene in this series may be seen on p. 92.)

The Good Samaritan, artist unknown, possibly New England, oil on maple wood, c. 1800-1825, 20 x 27⅛ inches, Abby Aldrich Rockefeller Folk Art Center, Williamsburg, Virginia.

Opposite: The parable of the Prodigal Son is a story of the separation of father and son, meaning, of course, the sinner estranged from God. After receiving his patrimony, the son leaves home for "a far country," well dressed, well shod, and well fed (Luke 15:13). The Prodigal represents the rebelliousness of youth and the sin of unbelieving, but his father, pointing to heaven reprovingly, remains ultimately hopeful and forgiving.

The Prodigal necessarily falls into sin with vain and greedy harlots described by one 17th-century commentator as "Satan's swine." Their vanity is displayed in the ornateness of their home; their greed is symbolized by the first harlot who possesses the son's hat and riding crop. It is essential — both to the parable and to the artist's rendering of it — that the Prodigal lose the "spiritual" clothing that he wore in his father's household. Such loss is the price of sin. (These scenes may be seen in color on pp. 110-111.)

The Prodigal Son Leaves Home and *The Prodigal Son When He Has No More Money,* Friedrich Krebs, Pennsylvania, watercolor and ink on paper, c. 1800, each 8½ x 13¼ inches, The Pennsylvania Historical and Museum Commission, William Penn Memorial Museum.

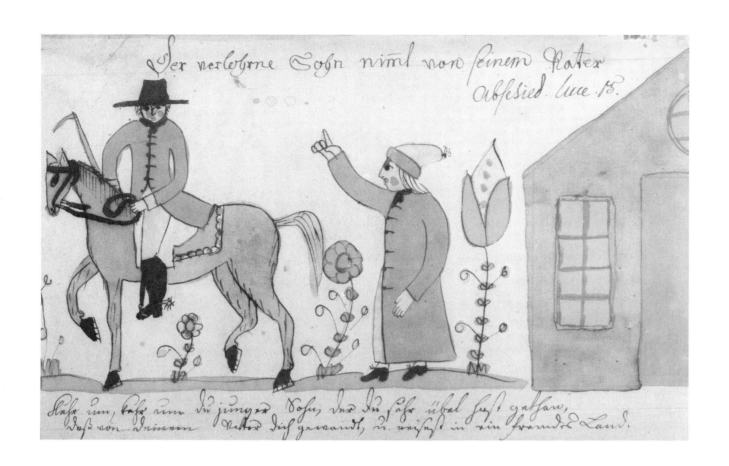

Der verlohrne Sohn nimt von seinem Vater
Abschied. Luce 15.

Kehr um, kehr um du junger Sohn, der du so sehr übel hast gethan,
daß von deinem Vater dich gesandt, u. reisest in ein fremdes Land.

Da er kein Geldt mehr hat, da ward er sehr veracht.

O Sohn, O Sohn, wie gehts so schlecht, daß man dich jetzt zum Hauß nauß schlägt,
Der Eltern Rath hast du veracht, drumm wirst von aller Welt verlacht.

After having lost all his "spiritual" goods through wordly dalliance, the Prodigal — now dressed in a swineherd's loose pants, shirt, and soft hat — is reduced to feeding animal swine, a natural consequence of his sporting with harlots. The wages of sin are here visually explicit.

The Prodigal Son in Misery, Friedrich Krebs, Pennsylvania, watercolor and ink on paper, c. 1800, 8½ x 13¼ inches, The Pennsylvania Historical and Museum Commission, William Penn Memorial Museum.

Starving, humble, and still barefoot, the Prodigal goes home, saying "Father, I have sinned against heaven and in thy sight." His father, arms outstretched in welcome, calls the servant to bring his best robe of holiness, his ring of inward grace, and his shoes of true freedom and spiritual comfort, "for this my son was dead, and is alive again; he was lost, and is found." The meaning of repentence has perhaps never been better defined.

The Prodigal Son Returns to His Father, Friedrich Krebs, Pennsylvania, watercolor and ink on paper, c. 1800, 8½ x 13¼ inches, The Pennsylvania Historical and Museum Commission, William Penn Memorial Museum.

The famous miracle of Jesus turning water into wine at Cana is portrayed in this Swedish painted cloth. The wedding supper is in progress in a neoclassically-proportioned church, in which the viewer peers as if witnessing a cutaway stage set. Jesus — frequently portrayed in conjunction with chandeliers in Protestant bibles of the 17th century — sits under such a fixture between the bride and groom. That there are thirteen present at the feast is a conscious realization that the wedding feast foreshadows the Last Supper.

The Wedding in Cana in Galilee in the Land of Judea AOS 1854, Anders Olsson, Swedish, bonader oil on linen, 47½ x 54 inches, Museum of New Mexico Collection.

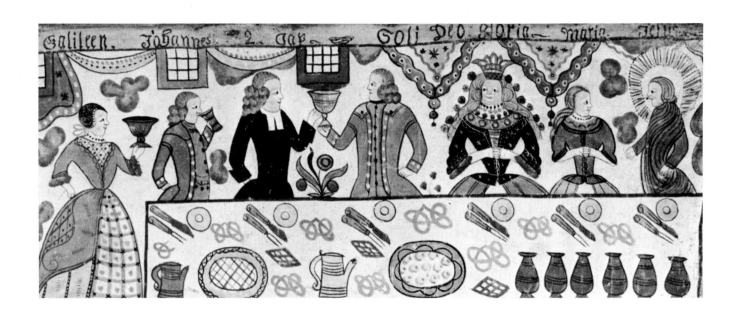

This detail of a larger scene is of particular interest because of the table setting. As in the biblical story of the wedding feast (John 2) there are "six water pots of stone," but the artist, clearly understanding the scriptural story as a foretelling of the Eucharist, has provided "bread" in the form of pretzels. (According to medieval legend, a French monk formed the first pretzel with three twists representing the Trinity.) The flatware is a contemporary European touch as are the 18th-century costumes. Interestingly, in the complete painting there are thirteen guests at the wedding supper.

Marriage Feast at Cana, detail from *The Life of Christ,* artist unknown, Swedish, paint on linen, 1794, Nordisk museet.

Opposite: In all likelihood, a schoolgirl has here rendered quite literally the famous story in St. John's Gospel (2:5-29) of Jesus and the Woman of Samaria at the well. In the story Jesus sits by the well as the woman approaches with her water pot, somewhat apprehensive of the stranger who asks her for water to drink. There is no attempt in this simple picture to delve into the theological meaning of the two kinds of water that Jesus speaks of. Rather, the very setting itself is meant to suggest that meaning to viewers already familiar with the story.

Christ and the Woman of Samaria, artist unknown, probably American, silk and watercolor on silk, c. 1825, 20½ x 27¼ inches, The Abby Aldrich Rockefeller Folk Art Center, Williamsburg, Virginia.

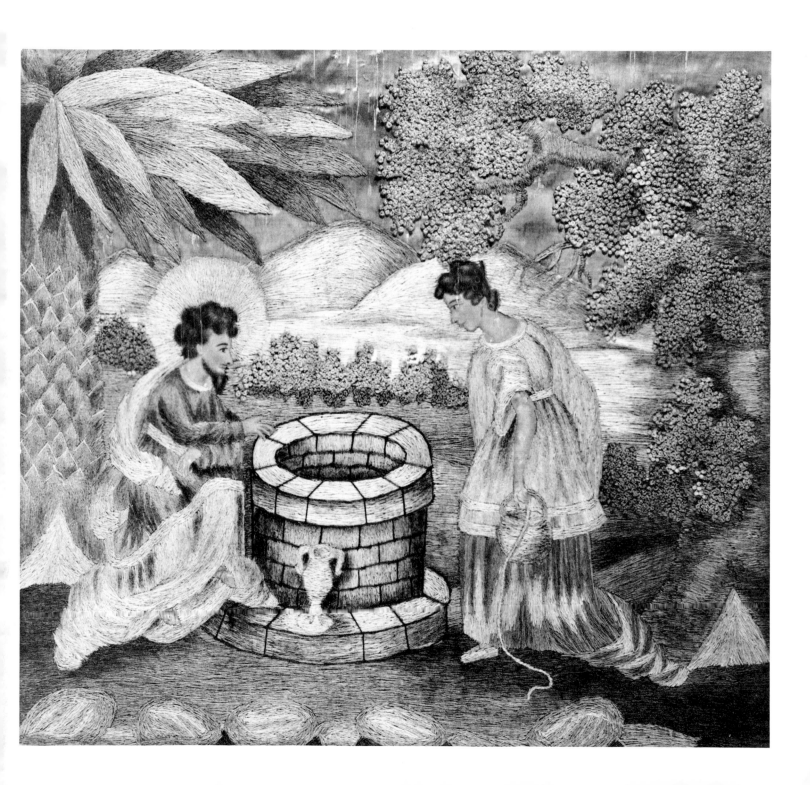

As in the picture of the wedding feast at Cana (see p. 119), the table around which Jesus and his disciples gather is set with unleavened bread (pretzels) and wine — as well as with 18th-century dinnerware. But with the Paschal lamb centered (as is Jesus, the Lamb of God), the setting is the Passover feast, and Jesus's utterance, "Father, the hour has come . . . ," signifies that the Passover meal and the Old Law will be replaced by the New Meal (Eucharist) and the New Law.

The Last Supper, detail from *Bible Scenes,* artist unknown, Swedish, paint on linen, c. 1800, Nordiska museet.

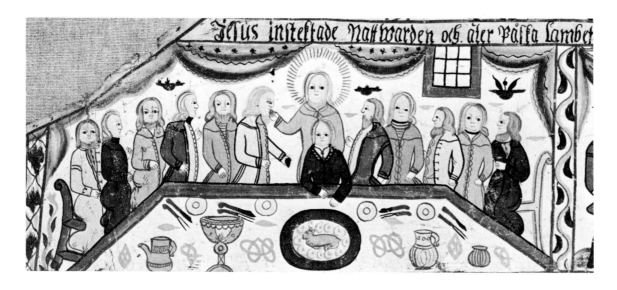

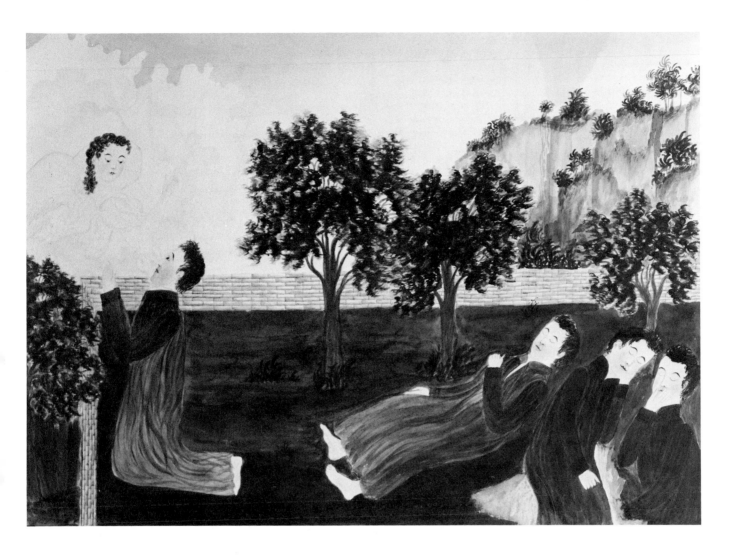

The full title of this watercolor is aptly descriptive: "Jesus Christ agonizeth in the garden of Gethsemane & is comforted and strengthened by an Angel from Heaven. The three disciples Peter, James & John, whom Jesus left to watch while He went to pray, are overcome by sorrow and fall asleep." This anonymous work, in which the biblical description of the walled olive orchard near the brook Cedron and the Mount of Olives is quite literally portrayed, is distinctive in its presentation of Jesus as a mortal man among other men. The graceful olive trees, in full leaf during the Paschal season, reinforce the meaning of the story: the olive was long a symbol of resurrection because, before an old tree is dead, it sends up new shoots to continue its life.

Agony in the Garden of Gethsemane, artist unknown, American, watercolor on paper, 19th century, 14½ 14½ x 18½ inches, Kennedy Galleries, Inc.

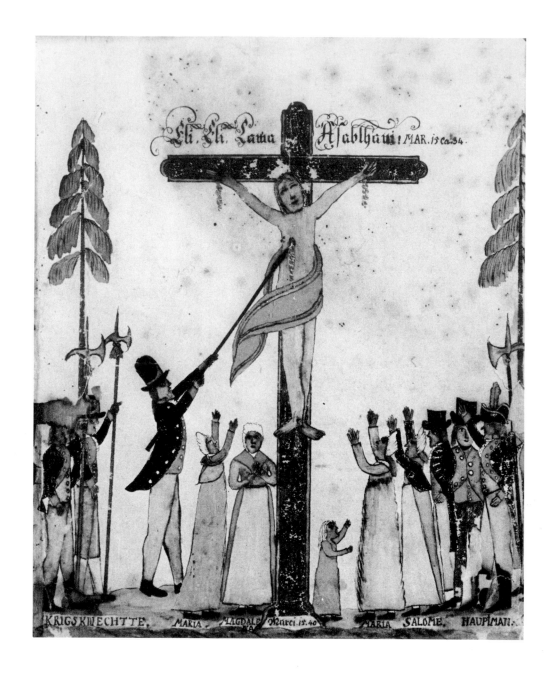

Standing below the cross in the crowd of townspeople and soldiers is the centurion who recognizes Jesus as the Christ, and four women (sometimes referred to as the Four Marys) — Mary Magdalene, the repentant sinner; Mary Jacobus, the mother of James the Less; Salome, the mother of James the Greater; and Mary, the mother of Jesus. The presence of women at the Crucifixion and at the Ascension can be explained by the allegorical representation of womankind who, since Eve, has been a messenger of life and of death.

The Crucifixion, artist unknown, American, watercolor on paper, c. 1800, 9½ x 7½ inches, The Metropolitan Museum of Art, gift of Mrs. Robert W. de Forest.

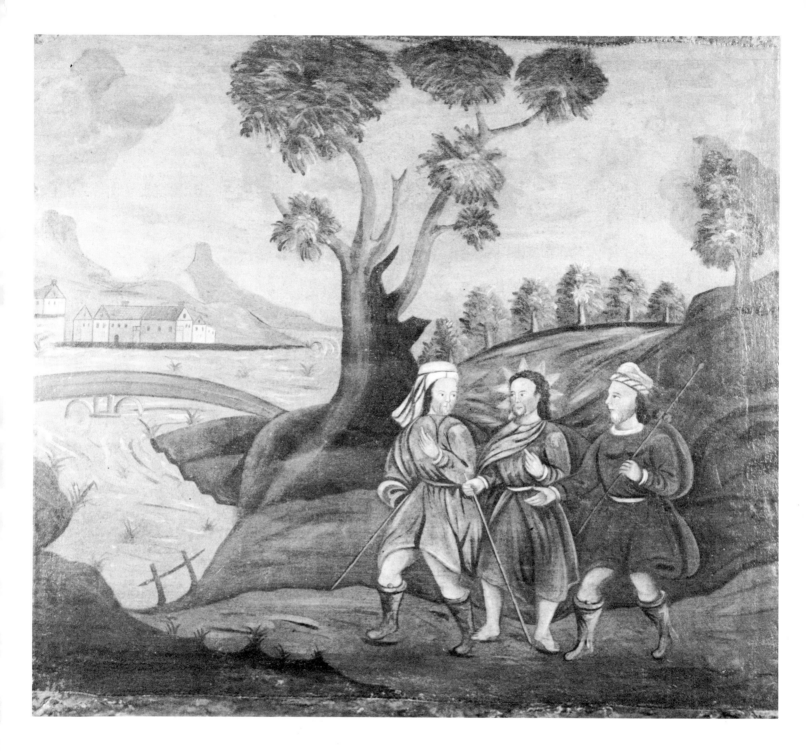

Two pilgrims, with boots, caps, and staffs, walk with a stranger "three-score furlongs" (Luke 31.13) to a village called Emmaus. They recognize the man in otherworldly clothes later when they break bread together, but, while they walk and talk of Jesus's death, they remain unaware of the risen Christ's presence. The pilgrim at the right carries a scrip, a traveler's knapsack, for centuries an iconographic attribute of pilgrims.

Christ on the Road to Emmaus, artist unknown, probably Albany, New York, oil on canvas, 18th century, 32½ x 24½ inches, Albany Institute of History and Art, Albany, New York.

The Acts of the Apostles, that most missionary of all biblical books, contains few more vivid stories than that of Philip and an Ethiopian eunuch of great authority who was admitted by baptism into Christian fellowship. Although the landscape, the camels, and the servants are not mentioned in the biblical story itself, the artist has taken great care to include the chariot, still containing the scroll of Isaiah which had led directly to the Ethiopian's conversion.

Philip Baptizing the Eunuch, R. Campbell, line engraving on wove paper for *Brown's Bible* (New York, 1822), 17⅜ x 10½ inches, The Henry Francis du Pont Winterthur Museum.

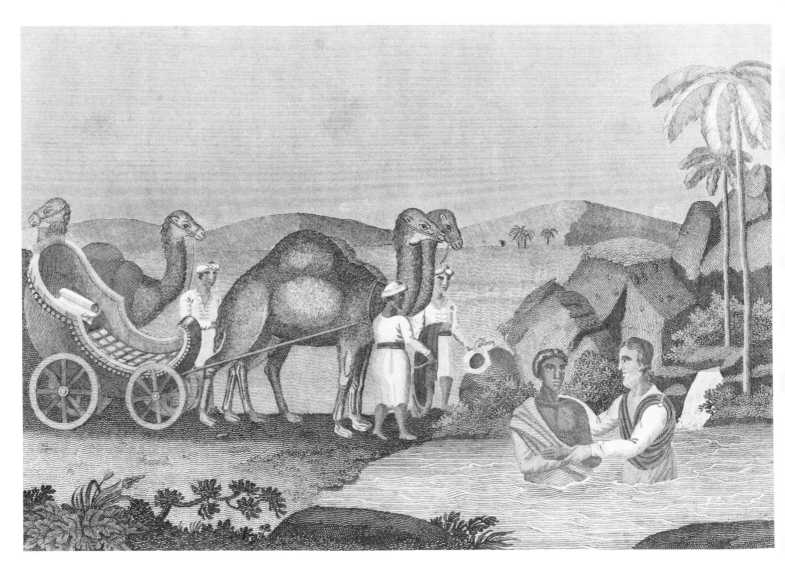

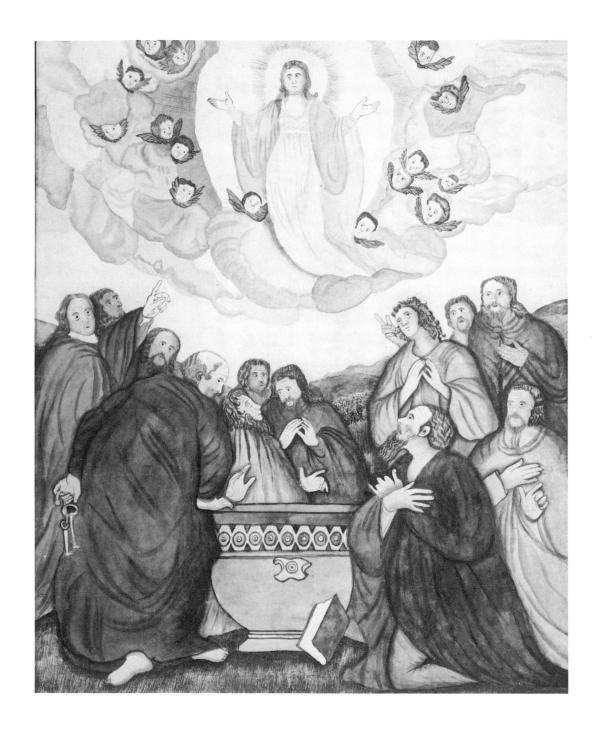

Jesus appears visibly, and for the last time, before the eyes of the apostles after having already appeared to the Marys and to the pilgrims on the road to Emmaus. The Ascension is recorded with great restraint in Acts 1:9, the biblical source of this painting: "And a cloud received him out of their sight."

Christ's Ascension, Eunice Pinney, Connecticut, paint on paper, c. 1815, 23 x 19 inches, Courtesy of Sotheby Parke Bernet, Inc.

SELECT BIBLIOGRAPHY

Cott, Nancy. *The Bonds of Womanhood: "Woman's Sphere" in New England, 1780-1935.* New Haven: Yale University Press, 1977.

Douglas, Ann. *The Feminization of American Culture.* New York: Alfred A. Knopf, 1977.

Freeman, Rosemary. *English Emblem Books.* London: Chatto & Windus, 1948.

Kauffman, C. M. *The Bible in British Art: 10th to 20th Centuries.* London: Victoria and Albert Museum, 1977.

Mâle, Emile. *Religious Art: From the Twelfth to the Eighteenth Century.* Originally published as *L' Art Religieux du XIIe au XVIIIe Siecle* in 1949. New York: The Noonday Press, 1972.

Miller, Perry and Thomas H. Johnson. *The Puritans.* New York: Harper & Row, 1963.

Robertson, D. W., Jr. *A Preface to Chaucer: Studies in Medieval Perspectives.* Princeton: Princeton University Press, 1962.

Smith, Elwyn A. *The Religion of the Republic.* Philadelphia: Fortress Press, 1971.

Springer, Lynn E. "Biblical Scenes in Embroidery" in *Needlework: An Historical Survey,* ed. Betty Ring. New York: Universe Books, 1975.

Stewart, Stanley. *The Enclosed Garden.* Milwaukee: The University of Wisconsin Press, 1966.

Welter, Barbara. *Dimity Convictions.* Columbus: Ohio University Press, 1976.

Wright, Louis B. *Middle-Class Culture in Elizabethan England:* Chapel Hill: The University Press, 1935.

_____ . *Religion and Empire: The Alliance Between Piety and Commerce in English Expansion 1553-1625.* Chapel Hill: The University of North Carolina Press, 1943.